CREATIVE COMMUNITY THE ART OF CULTURAL DEVELOPMENT

by Don Adams and Arlene Goldbard

©2001 The Rockefeller Foundation
420 Fifth Avenue
New York, NY 10018-2702

Design by Lisa Billard Design, New York

Library of Congress Cataloging-in-Publication Data

Adams, Don.
 Creative community: the art of cultural development / by Don Adams
and Arlene Goldbard.
 p. cm.
 Includes bibliographical references.
 ISBN 0-89184-052-4
 1. Arts and society—United States. 2. Community art
projects—United States. I. Goldbard, Arlene. II. Title.
 NX180.S6 A26 2001
 700'..1'030973—dc21 2001017457

Cover: Dozens of young people from Los Angeles helped create the first
phase of Social & Public Art Resource Center's Great Wall mural in the
Tujunga Flood Control Channel in Van Nuys, California, from 1976 through
1983. Photo © SPARC 1976, 1983

Title page: Great Wall team members cool off after working on the
Van Nuys, California mural. Photo © Judith F. Baca 1976, 1983

Page 120: Liz Lerman Dance Exchange senior adult members in a creative
movement class. Photo © Stuart Bratesman 1988

As the Rockefeller Foundation has charted new directions to meet the challenges of a new millennium, we have revised and reinterpreted our core mission of promoting the well-being of humankind to focus on the enriched lives and sustainable livelihoods of people who are poor and/or excluded from the benefits of an increasingly globalized world. The Creativity & Culture theme has endeavored to maintain and build on the Foundation's tradition in the arts and humanities of an "assertive humanism," responsive to contemporary social conditions. These issues, complex and interrelated, include: the global proliferation of mass media and concomitant loss of traditional means of cultural transmission; migration and increased voice/recognition of previously excluded communities; clashes of value systems; and the disproportionate gains and losses of globalization.

Artists and others in the field we are calling community cultural-development are naturally responding to these same challenges. In order to support these cultural efforts to advance social change and nurture community resilience, in 1993 the Foundation initiated a competitive program called Partnerships Affirming Community Transformation, or PACT. In 1999, we asked Don Adams and Arlene Goldbard, who have extensive experience in community cultural-development, to take stock of the work supported thus far through PACT. Arlene was a staff artist at the San Francisco Neighborhood Arts Program from 1971–73, while Don was doing cultural development projects in rural South Dakota. In 1979, Don and Arlene became co-directors of the Neighborhood Arts Programs National Organizing Committee. Since then they have continued to work with scores of artists and groups involved in advancing social inclusion and empowerment through the arts and culture.

We found their report so useful that we asked them to revise it for publication, adding a historical section and bibliography so that their insights could be shared more broadly. It is our hope that this report will help to further develop both the theory and practice of community cultural-development.

LYNN SZWAJA
Acting Director, Creativity & Culture
February 2001

OUR TOPIC TURNS ON A PARADOX. THE COMMUNITY CULTURAL-
DEVELOPMENT FIELD IS GLOBAL, WITH A DECADES-LONG HISTORY
OF PRACTICE, DISCOURSE, LEARNING AND IMPACT.

In Europe and much of the developing world, the work of the field
was recognized by cultural authorities, development agencies and
funders as a meaningful way to assist communities coping with
the forces of modernization. As the phenomenon of globalization
accelerates, trailing protest in its wake, community cultural-
development practice is more and more widely recognized as
a powerful means of awakening and mobilizing resistance
to imposed cultural values.

1

CHAPTER ONE

THE COMMUNITY CULTURAL-DEVELOPMENT FIELD

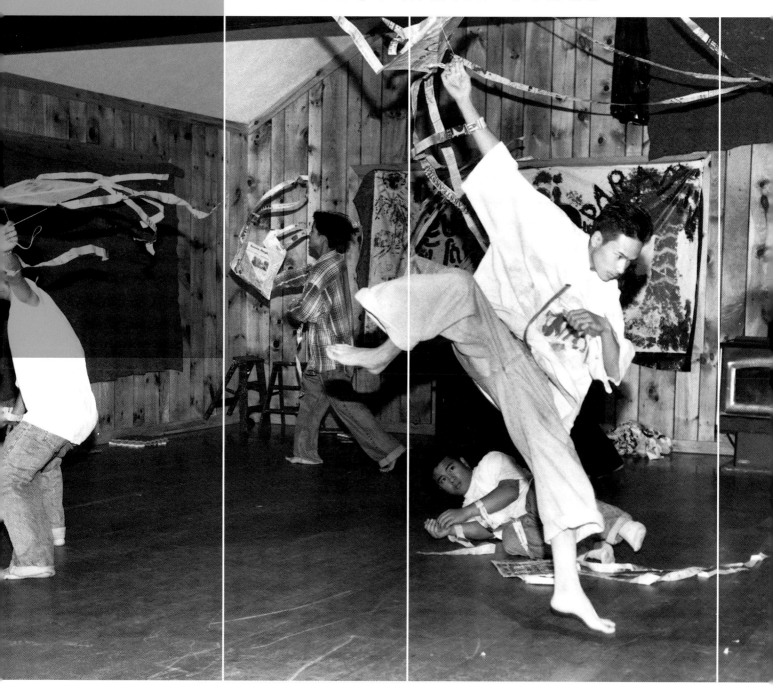

But the United States's active community cultural-development field is nearly invisible as a phenomenon. There has been no sustained support for community cultural-development per se in the United States, forcing practitioners to struggle for legitimation. Because it employs the same art forms as conventional arts disciplines (e.g., dance, painting, film), work in the field has mostly been treated as a marginal manifestation of mainstream arts activities—for instance, as "community-based theater projects," competing for a tiny fraction of theater-oriented funding; or as "audience development initiatives," arguing for their role in nurturing new audiences by bringing new people into contact with arts work. The result is a U.S. field that appears atomized and dispersed, with no clear identity as a profession. Constantly reinventing arguments to convince funders of the legitimacy of their efforts, constantly reframing their work to fit the guidelines of social-service or conventional arts-discipline funders, community artists have been unable to develop the infrastructure that legitimates a profession—its own widely accepted standards, journals of theory and practice, training initiatives and support sources.

Indeed, people in the United States don't even know what to call this category of social action. Many different names are in simultaneous use:

Community arts. This is the common term in Britain and most other Anglophone countries; but in U.S. English, it is also sometimes used to describe conventional arts activity based in a municipality, such as "the Anytown Arts Council, a community arts agency." While in this document we use "community artists" to describe individuals engaged in this work, to avoid such confusion we have chosen not to employ the collective term "community arts" to describe the whole enterprise.

Community animation. From the French *animation socio-culturelle*, the common term in Francophone countries. There, community artists are known as *animateurs*. This term was used in much international discussion of such work in the 1970s.

Cultural work. This term, with its roots in the panprogressive Popular Front cultural organizing of the '30s, emphasizes the socially conscious nature of the work, stressing the role of the artist as cultural worker, countering the tendency to see art making as a frivolous occupation, a pastime as opposed to important labor.

"Participatory arts projects," "community residencies," "artist/community collaborations"—the list of labels is very long. Even though it is a mouthful, we prefer "community cultural-development" because it encapsulates the salient characteristics of the work:

– *Community*, to distinguish it from one-to-many arts activity and to acknowledge its participatory nature, which emphasizes collaborations between artists and other community members;

– *Cultural*, to indicate the generous concept of culture (rather than, more narrowly, art) and the broad range of tools and forms in use in the field, from aspects of traditional visual- and performing-arts practice, to oral-history approaches usually associated with historical research and social studies, to

< Asian youth perform in 1997 in the "Looking In/To The Future" project of New WORLD Theater in Amherst, Mass. Photo © Edward Cohen 1997

use of high-tech communications media, to elements of activism and community organizing more commonly seen as part of nonarts social-change campaigns; and

– *Development*, to suggest the dynamic nature of cultural action, with its ambitions of conscientization (explained in Glossary) and empowerment and to link it to other enlightened community-development practices, especially those incorporating principles of self-development rather than development imposed from above.

Within the community cultural-development field, there is a tremendous range of approach, style and outcome—every aspect of the work. The balance of this volume provides a more complete description.

CULTURAL RESPONSES TO SOCIAL CONDITIONS > Community cultural-development work is inevitably a response to current social conditions. The precise nature of this response always shifts as social circumstances change. In the period since the '60s—the decades that have shaped the current field—these forces have been, as Machiavelli put it so elegantly half a millennium ago, "...like the hectic fever which, as the doctors tell us, at first is easy to cure though hard to recognize, but in time, if it has not been diagnosed and treated, becomes easy to recognize and hard to cure."[1]

GLOBAL PROLIFERATION OF MASS MEDIA

Since the advent of radio, motion pictures and television, penetration of commercial mass-media products around the globe has proceeded at a pace unparalleled in history. In its wake have arisen several disturbing social trends:

– the breakdown of traditional multidirectional means of cultural transmission and preservation in favor of the unidirectional transmission of mass-produced cultural products such as film, television and recorded music;

– the creation of a global youth market that has broken long-standing patterns of transmission for traditional cultural heritage, effectively alienating youth from cultural roots and substituting products for an immaterial legacy; and

– the pervasive passivity of consumer culture overtaking live, in-person activities that bring people into the commons and into direct contact with each other, with an attendant decline in the vitality of civil society.

We do not mean to suggest a simple dichotomy here: commercial culture, bad; traditional culture, good. Along with the products they exist to sell, commercial cultural industries have indeed sometimes spread liberatory ideas of individual choice and social mobility. As Robert McChesney has pointed out:

Global conglomerates can at times have a progressive impact on culture, especially when they enter nations that had been tightly controlled by corrupt media crony systems (as in much of Latin America) or nations that had significant state censorship over media (as in parts of Asia).[2]

1 Niccolò Machiavelli, *The Prince*, written 1513, translated by Thomas G. Bergin (New York: Appleton-Century-Crofts Educational Division, 1947), p. 6.

2 Robert W. McChesney, "The New Global Media," *The Nation*, Vol. 269, No. 18 (Nov. 29, 1999), p. 13.

Because commercial media have one imperative—to expand profits through expansion of their clientele—constraints such as cronyism and state control are viewed merely as temporary obstacles, glitches in a larger marketing plan. When such obstacles are overcome, the net result is to expose populations to a broader range of news, a wider spectrum of programming suggesting new life-possibilities—as well as virtually unlimited opportunity to arouse new needs that can be fed in the marketplace. But the progressive impact of global conglomerates does not extend so far as to incite political change, since transnational corporations, in media as in other fields, are intrinsically conservative, always preferring a stable climate over the volatility that leads to rebellion or revolution.

The advent of new media has also softened the distinction between consumption and participation. When you sit in front of a computer "conversing" with other computer users, are you an active participant in the life of a particular (albeit virtual) community? Or have you merely succumbed to the enchantment of seeing your own words on television? These questions will remain unsettled for some time. Without dismissing the genuine cause for hope represented by new technologies' democratic potential, any provisional judgment should be based on mass media's impacts to date, not their unrealized possibilities. If advocates of free cyberspace prevail, the trend may be reversed; but until then, surely the channeling of cultural energy into consumer choices is the primary effect of current arrangements.

The formidable challenge lies in allowing people a larger, more meaningful choice, as articulated by Amadou Mahtar M'Bow, former Director-General of UNESCO:

> The only pertinent question facing us today is not only of choosing between an outdated past and imitation of the foreign but of making original selections between cultural values which it is vital to safeguard and develop—because they contain the deep-lying secrets of our collective dynamism—and the elements which it is henceforth necessary to abandon—because they put a brake on our facility for critical reflection and innovation. In the same way we must sort out the progressive elements offered by industrial societies, so as only to use those which are adapted to the society of our choice which we are capable of taking over and developing gradually by ourselves and for ourselves.[3]

Because American consumer cultural industries are inarguably the main generators of commercial cultural products, many other nations have mobilized to protect themselves from this onslaught from Hollywood—for instance, by enacting legislation mandating a certain percentage of "domestic content" on their own airwaves or by taxing American product to finance indigenous media development. But within the United States, there has been only minimal regulation of commercial exploitation of broadcast media and other cultural industries, and no organized effort has succeeded in highlighting the need to protect living cultures from the deadening effects of a surfeit of mass media.

The U.S. role in international discourse concerning this problem has been to vigorously dismiss it as no problem at all: the U.S. government has never reversed Ronald Reagan's 1984 decision to leave UNESCO (the United Nations Educational, Scientific and Cultural Organization), the primary interna-

3 Amadou Mahtar M'Bow, "Opening of Leo Frobenius Seminar," *Cultures*, 6, No. 2 (1979), p. 144.

tional forum for such dialogue. (The United Kingdom, which withdrew from UNESCO at the same time, rejoined in 1997.)

On those pre-1984 occasions when an official American voice joined the UNESCO dialogue, it was to reject any "internationally imposed cultural standards or norms limiting, in any way, the rights of individuals.... Our cultural policy is a policy of freedom."[4] The classic translation of this language was provided by French cultural minister Jack Lang: "Cultural and artistic creation is today victim of a system of multinational financial domination against which it is necessary to get organized.... Yes to liberty, but which liberty? The liberty...of the fox in the henhouse which can devour the defenseless chickens at his pleasure?"[5]

In the nearly two decades since these positions were put forward, global saturation of American commercial media product has reached undreamed-of levels, a core component of the complex now referred to as "globalization."

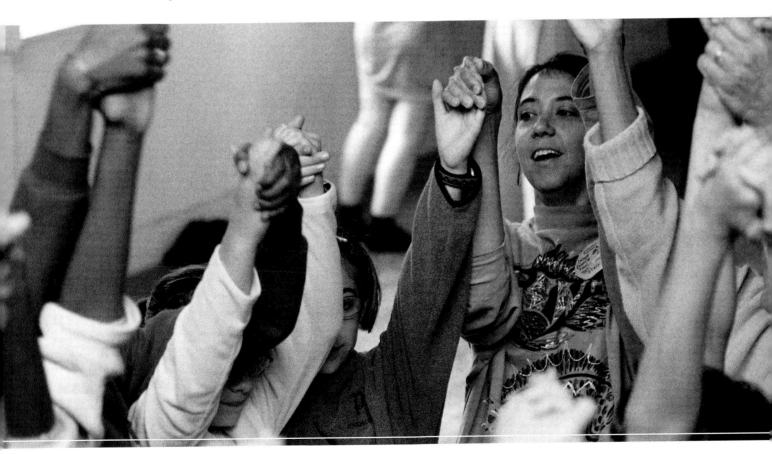

Liz Lerman Dance Exchange artists lead a children's workshop at Jacob's Pillow. Photo © Michael Van Sleen 2000

4 Jean Gerard, United States Ambassador to UNESCO, at the organization's global cultural policies conference in Mexico City, August 1982.

5 Jack Lang, French Cultural Minister, at UNESCO's global cultural policies conference in Mexico City, August 1982.

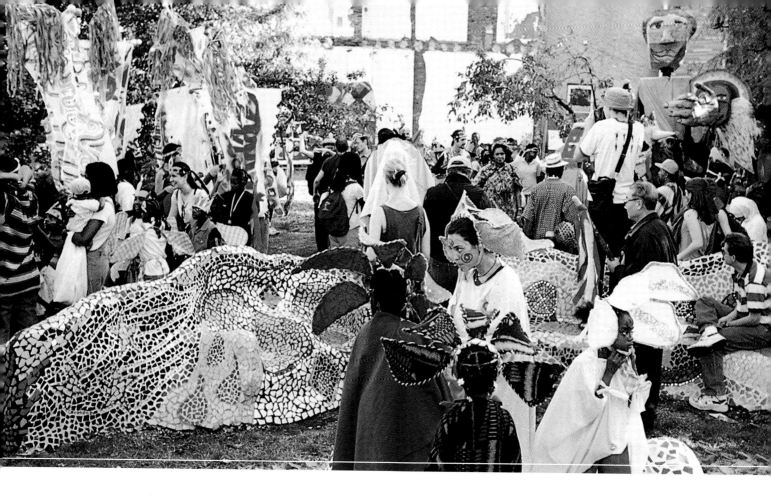

From the October 2000 Kujenga Pamoja annual harvest festival, taking place amidst community-created >

MASS MIGRATIONS

The social upheavals and violent conflicts of the last four decades have produced an unprecedent-ed flood of refugees and exiles. Certain situations are familiar to consumers of news. For example, the visibility of the Dalai Lama has brought attention to the way Chinese domination has endangered tradi-tional Tibetan culture and to the massive emigration of Tibetans from their homeland. Many less visible crises have contributed to the primary flow of refugees from South to North. While it is possible to maintain some cultural continuity in diaspora, there is no question that being forcibly uprooted from one's homeland leads to cultural deracination, which in turn leads to anomie.

> *This latest project is the biggest challenge ever... These newer [Southeast Asian] immi-grants—most are refugees and they have a different mind-set [than previous immigrant groups], ...youth violence, high failure rates and a real void in leadership from these com-munities. So we're trying partnerships with emerging organizations and social-service agencies and trying to find strategies for program development; but all of this is very com-plex. It raises many issues. It takes work, care, negotiation, leadership skills. Amazing stuff comes out and healing. But I'm putting out fires all the time.*[6]

6 This quotation and all other unattributed quotations are drawn from confidential interviews conducted by the authors with artists and organizers involved in community cultural-development projects in the United States in 1998 and 1999.

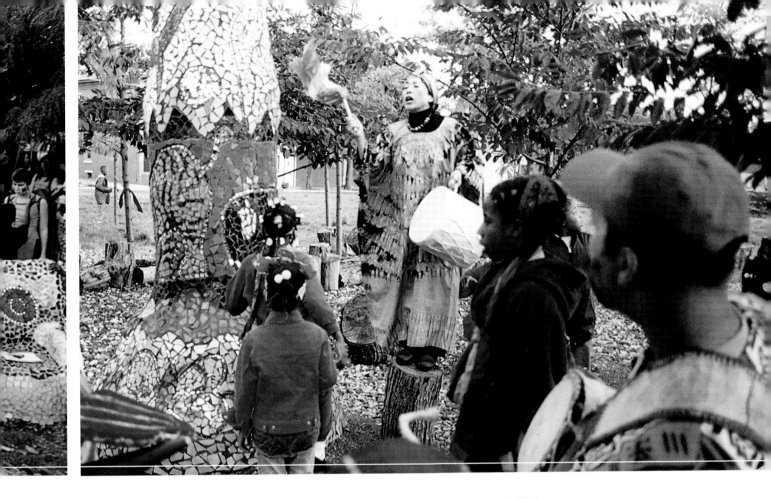

sculptures by Philadelphia's Village of Arts and Humanities. Photo © Matthew Hollerbush 2000

Within the United States, the dynamic has been similar, especially during the '60s and '70s, when urban renewal projects (known to those they displaced as "urban removal") banked on ending poverty and urban blight by demolishing inner-city neighborhoods, forcing the inhabitants to relocate, thus eliminating both the material and immaterial networks that previously sustained local culture. These internal migrations have been further complicated by ongoing transformation of the American cultural landscape through immigration, leading in recent years to a resurgent backlash of anti-immigrant feeling.

RECOGNITION OF CULTURAL MINORITIES

Ours has been an era of cultural particularization, marked by what the Mexican writer Carlos Fuentes has called "the emergence of cultures as protagonists of history."[7] The question of whether they are protagonists in a tragedy or triumph is not settled.

In the United States, we have seen growing recognition of minority cultures as distinct and different in character, reflected in better textbook histories and school curricula; the availability of ethnic foods, dress, literature and music; the proliferation of culturally distinct celebrations, festivals, observances. But at the same time, oppositional feeling and the incidence of persecution—synagogue fires,

7 Carlos Fuentes, *Latin America: At War With The Past*, Massey Lectures, 23rd Series (Toronto: CBC Enterprises, 1985), pp. 71-72.

anti-immigrant legislation, anti-Asian violence, organized white supremacist activity—have also become more visible through the media, even when their frequency has declined.[8]

Around the globe, "people turn to culture as a means of self-definition and mobilization and assert their local cultural values. For the poorest among them, their own values are often the only thing that they can assert."[9] The cultures of major European and American cities have become immeasurably more vibrant, diverse and lively as a result of such assertions. In many other parts of the world, the result has been more mixed, leading simultaneously to a greater overall autonomy—as in the key part Islamic culture played in overturning the Shah of Iran—and a corresponding lessening of freedom for individuals who wish to diverge from the presumed cultural consensus—as for those Iranians who were resistant to adopting the lifeways of fundamentalist Shiite Islam under the Ayatollah Khomeini.

Movements for national liberation frequently gain energy from suppressed religious loyalty, as in Iran. But the result is often framed as a choice between freedoms: on the one hand, a form of religious liberty that replaces secular oppression with theocracy, guaranteeing the right to certain types of religious expression; and on the other hand, the liberty of individuals to eschew belief, to reject the imposition of codes of behavior derived from fundamentalism. In such contests, individual liberty is often defeated. Though the consequences have sometimes been troubling, the fact of human diversity and the recognition of this fact have nevertheless unquestionably transformed our era.

"CULTURE WARS"

One of the characteristic themes of our period has been polarization of cultural values. The two contending camps have been fundamentalism and liberal humanism: on one side is the impulse to eliminate cultural expression that offends received religious and social beliefs; on the other, the impulse to promote free expression of divergent views.

We have seen countless manifestations, from the burning of books in revolutionary Iran to the hue and outcry over witchcraft in the Harry Potter series of children's stories. In the United States, there has been an unending stream of controversy over works of art that are perceived as dangerous when viewed from the fundamentalist camp: Robert Mapplethorpe's sexual images, Andres Serrano's and Chris Ofili's religious ones, Marlon Riggs's challenging transgressions of racial and sexual taboos.

8 There is a significant lag in statistical compilation, but the FBI's reported domestic hate crimes for the most recent available years declined overall from 8,049 in 1997 to 7,755 in 1998. (It is widely accepted that such crimes are underreported.) Within the overall statistics appeared certain contrary trends, such as a 14 percent increase in crimes based on sexual orientation. The Anti-Defamation League reported a 2 percent upturn in anti-Semitic incidents in 1998, after a three-year decline, but after that slight rise, incidents declined by 4 percent in 1999. As the ADL reported in its *1999 Audit of Anti-Semitic Incidents*, "Ironically, the latest decrease occurred in a year that also saw three of the most violent anti-Semitic incidents in many years, during the late spring and summer. On June 18, three synagogues were set afire in the Sacramento, Calif., area... On the July 4 weekend, a lone gunman went on a shooting rampage in the Midwest, killing two and seriously wounding eight, including six Chicago-area Jews. On August 10, a lone gunman walked into a Los Angeles day-care center and opened fire, injuring five people."

9 *Our Creative Diversity: Report of the World Commission on Culture and Development*, Sec. Ed. (Paris: UNESCO Publishing, 1996).

In the community cultural-development field, these "culture wars" (Pat Buchanan's rubric has become the label of choice across the political spectrum) have most often arisen around works of public art: for instance, the "zero tolerance" crime-fighting campaign of Los Angeles' Mayor Riordan has led police to demand the obliteration of alternative-history murals in communities of color. Images that have been singled out include a Black Panther and a mestizo from the Mexican Revolution, on the grounds that portrayals of past rebellion will inspire fresh revolt.

GLOBALIZATION

Many of the conditions discussed above can be understood as phenomena of globalization, the increasing irrelevance of national boundaries and interdependence of worldwide trade, capital and population.

Already it is clear that while some have gained from the forces of globalization, many have lost:

> Over a billion poor people have been largely bypassed by the globalization of cultural processes. Involuntary poverty and exclusion are unmitigated evils.... [A]ll too often in the process of development, it is the poor who shoulder the heaviest burden. It is economic growth itself that interferes with human and cultural development. In the transition from subsistence-oriented agriculture to commercial agriculture, poor women and children are sometimes hit hardest. In the transition from a traditional society, in which the extended family takes care of its members who suffer misfortunes, to a market society, in which the community has not yet taken on responsibility for the victims of the competitive struggle, the fate of these victims can be cruel. In the transition from rural patron-client relationships to relations based on the cash nexus, the poor suffer by losing one type of support without gaining another. In the transition from an agricultural to an industrial society, the majority of rural people are neglected by the public authorities in favour of the urban population. In the transitions that we are now witnessing from centrally planned to market-oriented economies and from autocracies to democracies, inflation, mass unemployment, growing poverty, alienation and new crimes have to be confronted....
>
> As a result of accelerated change, the impact of Western culture, mass communications, rapid population growth, urbanization, the break-up of the traditional village and of the extended family, traditional cultures (often orally transmitted) have been disrupted. Cultures are not monolithic and the elite culture, often geared to global culture, tends to exclude the poor and powerless.[10]

Globalization's most obvious impacts have limited the ability of the poor and excluded to earn decent livelihoods. But advanced development thinkers such as the economist Amartya Sen[11] have made it clear that impoverishment and exclusion are not matters merely of economic power. It has been well-demonstrated, for instance, that life expectancy and health do not correlate neatly with per capita income: the citizens of Kerala, in India, have higher literacy rates and longer life expectancies than inner-city African-American men, whose average income is substantially higher. Sen's Nobel Prize-

10 *Our Creative Diversity*, op. cit., p. 30.

11 See, for example, Sen's book *Development as Freedom* (New York: Knopf, 1999).

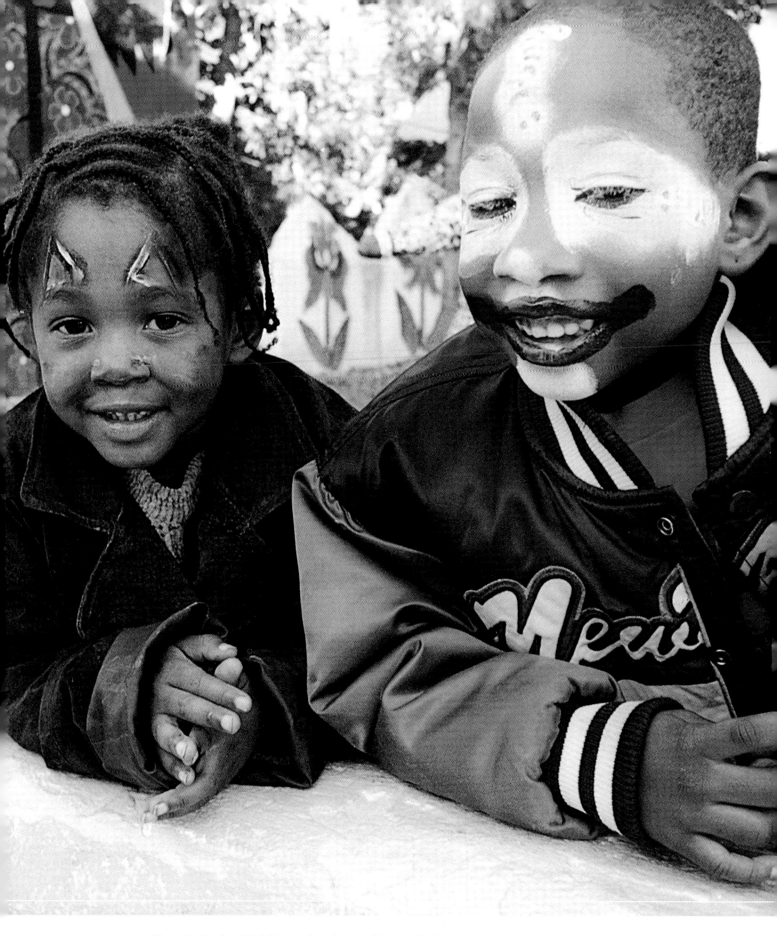

From the October 2000 Kujenga Pamoja annual harvest festival, which takes place amidst community-created scupltures by Philadelphia's Village of Arts and Humanities. Photo © Matthew Hollerbush 2000

winning work on the causes of famine demonstrated that free access to communications media is a most effective preventer of such human disasters, because an informed population will be able to learn and therefore address the causes of food shortage, almost always a problem of distribution (i.e., caused by political corruption or market abuses) rather than one of supply.

Yet the forces driving globalization are preeminently, almost exclusively economic: the push to open new markets, to consolidate and dominate those that have been established. While new information technologies hold great promise for increasing communication around the globe and thus cooperation toward greater freedom, their distribution is being determined largely by market forces, creating a growing digital divide between the haves and have-nots.

In this climate of inequality, the problems of how to distribute social goods in ways that lead to global inclusion—among them, freedom of expression and association and the right to culture with all it implies—do not seem to be on the agendas of transnational corporations. Weakened public sectors seldom demonstrate the will or ability to place them there, despite considerable popular sentiment in their favor, as demonstrated by opposition to the November 1999 World Trade Organization meeting in Seattle and to subsequent meetings around the world. In large part, it has been left to the third sector of NGOs (nongovernmental organizations), religious organizations, foundations and unions to seek a balance between the private pursuit of profit and the public good.

There is no indication that globalization will somehow bring about the reversal of its own destructive effects or even the amelioration of such effects. Rather, it demands responses that can exert powerful countervailing pressure. Community cultural-development efforts constitute one such response, making democratic counterforces of some of the same arts and media tools previously used to promote global saturation of commercial culture.

OVER TIME, PRACTITIONERS OF COMMUNITY CULTURAL-DEVELOPMENT
HAVE ADOPTED CERTAIN KEY PRINCIPLES TO GUIDE THEIR WORK. THERE
IS NO UNIVERSAL DECLARATION OR MANIFESTO. RATHER, EACH OF
THESE SEVEN POINTS HAS BEEN GIVEN A MULTITUDE OF DIFFERENT
EXPRESSIONS IN PRACTICE.

1: Active participation in cultural life is an essential goal of community cultural-development.

2: All cultures are essentially equal, and society should not promote any one as superior to the others.

3: Diversity is a social asset, part of the cultural commonwealth, requiring protection and nourishment.

4: Culture is an effective crucible for social transformation, one that can be less polarizing and create deeper connections than other social-change arenas.

5: Cultural expression is a means of emancipation, not the primary end in itself; the process is as important as the product.

6: Culture is a dynamic, protean whole, and there is no value in creating artificial boundaries within it.

7: Artists have roles as agents of transformation that are more socially valuable than mainstream art-world roles—and certainly equal in legitimacy.

2

UNIFYING PRINCIPLES

Elders Share the Arts recording older women's stories in Bronxdale, New York City. Photo © ESTA 1990

< "Hand-made Quilt," a large-scale montage created by artist George King and students of Atlanta's
 Humphries Elementary School from student photos of the hands of every student and staff member.
 Photo © George King 1986

1) ACTIVE PARTICIPATION IN CULTURAL LIFE IS AN ESSENTIAL GOAL OF COMMUNITY CULTURAL-DEVELOPMENT.

The supreme achievement of consumer culture is the "couch potato," the individual who has succumbed to the virtual existence available via remote-controlled television, eschewing the flesh-and-blood contact of social intercourse and direct participation in community life. Mass media substitute vicarious exposure for actual experience. Instead of sorting through the multiple layers of information one derives from real-life encounters, deciding for oneself what to treat as figure and what as ground, the couch potato orders from a limited menu cooked up by TV programmers and advertisers, with all information predigested for ease of consumption.

Entertainment is a fine thing, necessary leavening to existence. But a core belief of community artists is that an excess of such passivity is antithetical to civil society: the muscles of cultural participation atrophy with chronic under use, leaving a population in thrall to urgent-sounding messages beamed over the airwaves.

Viewed globally, it makes no difference whether such social passivity is promoted in aid of selling products or inculcating an official worldview. As Hans Magnus Enzensberger has written, it

> ...is essentially the same all over the world, no matter how the industry is operated.... The mind industry's main business and concern is not to sell its product; it is to "sell" the existing order, to perpetuate the prevailing pattern of man's domination by man, no matter who runs the society and no matter by what means.[12]

But however diligently the mind industry husbands its crop of couch potatoes, the harvest is always smaller than hoped. Human resilience and ingenuity cannot be undone by television broadcasts, as demonstrated by the many ways artists and activists have employed television imagery to subvert the aims of advertising. New computer-based media have begun to blur the boundary between passive consumption and active participation.

There is already an impressive body of evidence hinting at the interactive potential of such technologies, from their use by insurgent movements such as the Zapatistas to the sort of interactive portrait of a people, an "intercultural dialogue and a memory bank" of the Kurds photographer Susan Meiselas has created in her Web site <www.akakurdistan.com> (supported by the Rockefeller Foundation through a 1995 Film/Video/Multimedia Fellowship), to the way minority cultures have employed computers to maintain a sense of community in diaspora, as demonstrated, for example, in Daniel Miller's and Don Slater's treatment of the Internet in sustaining Trinidadian cultural identities in *The Internet: An Ethnographic Approach*.[13]

Still, there is a huge gap between the interactive, multidirectional communication such technologies could enable and the reality of the actual existing broadcast media with their dulling social impacts.

12 Hans Magnus Enzensberger, "The Industrialization of the Mind," *Critical Essays* (New York: Continuum, 1982), p. 10.

13 Daniel Miller and Don Slater, *The Internet: An Ethnographic Approach* (New York University Press, 2000).

Nearly 70 years ago, with newborn awareness of the power of electronic communications media, Bertolt Brecht wrote that:

> *Radio must be changed from a means of distribution to a means of communication. Radio would be the most wonderful means of communications imaginable in public life...if it were capable not only of transmitting but of receiving, of allowing the listener not only to hear but to speak and did not isolate him but brought him into contact.*[14]

Enzensberger makes the point that this presents not a technical difficulty, but a failure of social will:

> *[E]very transistor radio is, by the nature of its construction, at the same time a potential transmitter; it can interact with other receivers by circuit reversal. The development from a mere distribution medium to a communications medium is technically not a problem. It is consciously prevented for understandable political reasons.*[15]

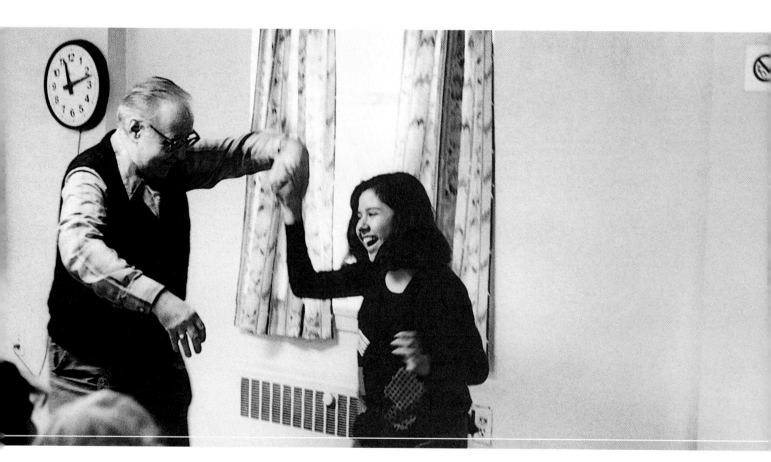

Dancers from New York City's Northside Senior Center and P.S. 17, brought together by Elders Share the Arts. Photo © Howard Pomerantz 1992

14 Bertolt Brecht, "Theory of Radio" (1932), *Gesammelte Werke*, quoted in Hans Magnus Enzensberger's "Constituents of a Theory of the Media," *Critical Essays*, op. cit., p. 49.

15 Hans Magnus Enzensberger, "Constituents of a Theory of the Media," *Critical Essays*, op. cit., pp. 48-49.

In our view, the remarkable democratizing potential of the media is so little developed and the forces exploiting the media for commercial ends are so powerful, that it is naive to suggest (as some cultural studies theorists have done) that the system can be effectively overturned by the individual agency of its consumers, deploying their power to concoct contrary meanings in their own minds.

In promoting initiative, creativity, self-directed and cooperative expression, community cultural-development practitioners hope to shatter a persistent media-induced trance, assisting community members in awakening to and pursuing their own legitimate aspirations for social autonomy and recognition.

2) ALL CULTURES ARE ESSENTIALLY EQUAL, AND SOCIETY SHOULD NOT PROMOTE ANY ONE AS SUPERIOR TO THE OTHERS.

The "right to culture" is an artifact of the 20th century, established through the United Nation's "Universal Declaration of Human Rights" of 1948: "Everyone has the right freely to participate in the cultural life of the community."

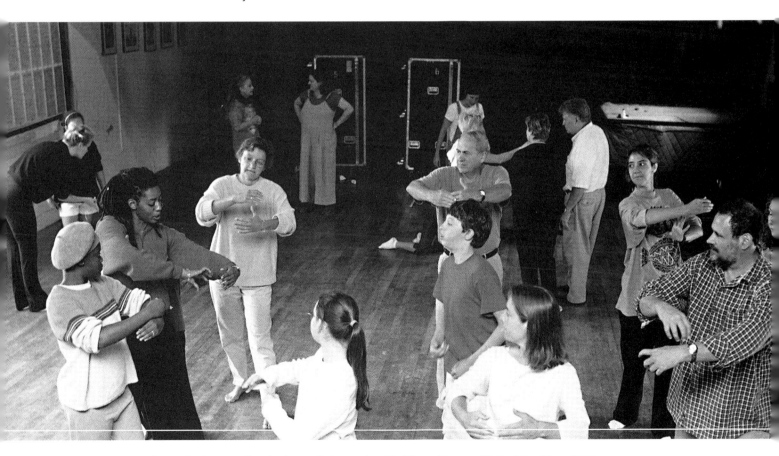

Liz Lerman Dance Exchange artists lead a workshop at Jacob's Pillow. Photo © Michael Van Sleen 2000

While this statement may seem unobjectionable at first glance, it has had far-reaching and contro-versial implications, as was pointed out in 1970 by René Maheu, then Director-General of UNESCO:

> *It is not certain that the full significance of this text, proclaiming a new human right, the right to culture, was entirely appreciated at the time. If everyone, as an essential part of his dignity as a man, has the right to share in the cultural heritage and cultural activities of the community—or rather of the different communities to which men belong (and that of course includes the ultimate community—mankind)—it follows that the authorities respon-sible for these communities have a duty, so far as their resources permit, to provide him with the means for such participation.... Everyone, accordingly, has the right to culture, as he has the right to education and the right to work.... This is the basis and first purpose of cultural policy.[16]*

A tenet of community cultural-development practice has been to demand public space, support and recognition for the right of excluded communities to assert their place in cultural life, to give expression to their own cultural values and histories. In the decades since the onset of the mid-20th century domestic civil-rights movements in the United States, much of this activity has centered on the struggle for recognition of minority cultures and for evenhanded treatment of those cultures' expressions through art and community life.

3) DIVERSITY IS A SOCIAL ASSET, PART OF THE CULTURAL COMMONWEALTH, REQUIRING PROTECTION AND NOURISHMENT.

As movements for civil rights and equality in society have gained momentum, on a parallel track, diversity has been problematized, with one widespread line of opinion suggesting that if people just downplayed their differences, we would all get along much better.

Community cultural-development practice is predicated on a very different paradigm—that what is needed is not a masking of real differences, but an appreciation and respect for them.

> *An issue that remains completely unresolved is race relations—interracial and intercultural issues. So many schisms in this country have to be addressed and art is a useful platform to address and find solutions to these dilemmas. Cultural programs are great mechanisms to articulate problems and to seek alternative solutions. The mainstream art world is in denial about these national crises; and many alternative organizations need...help...so they can develop networks, exchange information, find new ways to create work.*

Community artists' investigations of cultural difference often reveal deep commonalities within diversity: every culture has ways, however distinct, of encountering the universal in human experience from birth to death and many of these resonate across cultural barriers. But grasping such commonality always begins by encountering difference—whether based in place, ethnicity, age, orientation or other life condition—and framing it as something to treasure.

16 Augustin Girard, *Cultural Development: Experience and Policies* (Paris: UNESCO, 1972), pp. 139-140.

We [who live in the United States] have a unique opportunity as a country to show how diverse people can live in a global culture. We have more cultural diversity than any other country. To be civilized in the next century, we need to learn to deal with other cultures.

4) CULTURE IS AN EFFECTIVE CRUCIBLE FOR SOCIAL TRANSFORMATION, ONE THAT CAN BE LESS POLARIZING AND CREATE DEEPER CONNECTIONS THAN OTHER SOCIAL-CHANGE ARENAS.

Marxists used to speak in terms of "base" and "superstructure"; community organizers often distinguish between "hard" and "soft" issues; and in the electoral arena, it is a commonplace that voters will be moved more by money than by meaning ("It's the economy, stupid!" was the watchword of Bill Clinton's first campaign for president). But direct experience has convinced community artists that these are false dichotomies.

In practice, people speaking a cultural vocabulary—describing the social values that animate their community, explaining how they mark and honor milestones in the lives of individuals and in their joint histories, telling true stories of lived realities—can often reach a point of mutual comprehension seldom achieved through debates over "hard" issues. As one person we interviewed for this study stated,

This is a very important direction: to close the gap between the arts and communities. These approaches really can make this happen... Art is not something outside of their lives and communities. It's a collaborative, systemic way to work in the arts and culture around a social issue that's really transformative for a community, on its own terms.

Indeed, cultural action frequently serves as a form of preparation for social change. Perhaps the clearest examples derive from the "forum theatre" practice invented by Augusto Boal (discussed more fully in Chapter Four, Historical and Theoretical Underpinnings), whereby community members use theatrical techniques to plan, rehearse and refine strategies for action beyond the doors of the theater.

I don't think of politics as being different from theater. We are masks in the world. It's all about enriching the theatricality of daily life. It's a huge improv. This understanding really helps people decide how to act in the world. I used to think about politicizing theater and now it's the theatricalizing of politics.... We can quickly get to community urges and needs and get to problem-solving... This kind of theater is so accessible, so public and it engages everybody, whatever way they want: just to watch, to get involved. It's real pedagogy, real community learning.

5) CULTURAL EXPRESSION IS A MEANS OF EMANCIPATION, NOT THE PRIMARY END IN ITSELF; THE PROCESS IS AS IMPORTANT AS THE PRODUCT.

Some community cultural-development projects are entirely oriented to process, placing all emphasis on the transformation of consciousness experienced by participants as they discover and express their own cultural values; others place equal emphasis on outcomes, such as the creation of a CD or

video. But whereas outcome is everything in many conventional arts approaches—all that matters is what winds up onstage at curtain time—here, product is not permitted to overdetermine the nature of the project. What is most important is that the approach and aims are entirely consonant with the wishes of the participants.

> *Everybody brings something to the table and we need to help people figure out what that is, so they can have ownership.... There seem to be so many other priorities, but the arts allow us to imagine how the world could be different.... Quality involves the project leader's willingness to take risks and create partnerships that don't result in easy dialogues—real border-crossing. And they give a lot of credibility to the ideas participants are bringing into the project and provide a lot of tools to participants, so at the end they can make a space for themselves.*

The product/process question is not entirely settled, however. Occasionally, one hears it framed as "community versus quality."

On the grounds that beauty knows no class boundaries, that everyone deserves to experience work created with skill, ambition and intention, some community artists strive for the highest available production values, creating end products that compare favorably with the work of artists more conventional in approach. From this perspective, to demonstrate that the lives and stories of ordinary people can be the material of skillfully executed and powerful artworks makes a strongly positive social statement.

In contrast, on grounds rooted in a different sort of class analysis, other community artists reject end products they consider too slickly produced, too aesthetically similar to their art-world or commercial counterparts. From this perspective, a homemade or "folk" aesthetic seems most in keeping with community-based work, because it presents no barriers to comprehension, carries no off-putting social codes: community productions should look funky and approachable or else they risk looking intimidating.

The community/quality dichotomy invites posturing and polarization, supported by a thin reed of substance that almost topples under the weight of rhetoric it is made to carry. In truth, we see it as a red herring. No one sets out to make bad art. Using whatever means are accessible, most community artists (like most other artists) aim to make the products of their process-oriented work as good as they can be, judged by the criteria appropriate to the intention. To consciously execute something with less skill than one actually commands on the grounds that this is good enough for community work—surely the insult inherent in such a decision cancels any democratic intention that might motivate it.

6) CULTURE IS A DYNAMIC, PROTEAN WHOLE AND THERE IS NO VALUE IN CREATING ARTIFICIAL BOUNDARIES WITHIN IT.

The elite arts' status derives in part from epic efforts at purification and classification, segregating those enterprises deemed to be "high art" from the vulgarity of popular entertainments. Not much more than a century ago, a typical concert in a major American city might feature an operatic aria alongside a

Youth and seniors painting a mural entitled "Culture Builds Community" for New York Youth Services in an Elders Share the Arts project. Photo © ESTA 1998 >

comic poetry recital and an instrumental rendition of a piece of Romantic music; most museums exhibited a hodgepodge of painting and sculpture alongside curios and oddities—a piece of petrified wood or a fossil, a two-headed calf. Boundaries were put in place near the turn of the century by tastemakers anxious to shore up elite culture against an onslaught of immigrants.

Such distinctions persist today. (Although the advent of postmodernism has begun to cloud them in the arena of advanced art: Damien Hirst's dead cow is placed in the category of art because the arrangement and staging of the carcass express an artist's intention, whereas a taxidermist's staging of a two-headed calf is deemed to express only unfathomable Nature.)

Community cultural-development practice is marked by a willingness to draw on the entire cultural vocabulary of a community, from esoteric crafts to comic books—whatever resonates with community members' desire to achieve full expression. In talking about the work of a group that inspired her, one cultural organizer we interviewed said,

> I like their commitment to work with young people, to incorporate popular culture and really let them take charge.... It's really been transformative for them. That's what we're doing—trying to get young people to have hope that they can change their situations and deal with the challenges in schools.

7) ARTISTS HAVE ROLES AS AGENTS OF TRANSFORMATION THAT ARE MORE SOCIALLY VALUABLE THAN MAINSTREAM ART-WORLD ROLES—AND CERTAINLY EQUAL IN LEGITIMACY.

A main theme of the ongoing debate between community artists and the arts establishment has been whether community cultural-development practice deserves the label "art." It's not clear how much force this argument would have if money weren't attached; but if one is going to compete for scarce arts funding in the United States, it is necessary to assert one's standing as an artist, something community artists have been attempting to do since the '60s.

One reason longtime community artists have seemed to be winning the argument lately is that other artists working from within the establishment arts world—whose credentials, presuming they have acquired the proper signifiers such as degrees, a gallery or a good theatrical venue, are seldom subject to the same sort of scrutiny—have been adopting elements of community artists' approaches. For instance, increasing numbers of prestigious gallery artists and well-known performing artists are collaborating with nonartists and incorporating the work of nonartists into their completed productions. One veteran community artist, frustrated by this development, voiced concerns shared by many of our interviewees about the impact of inexperienced, personally ambitious people entering the field:

> Funders are not going toward uniquely creative work and now we're seeing bullshit work by people migrating into the field...without the same heart for the work: they'll paint at any cost.... You find municipal arts administrators and funders doing their own processes. They

look at successful projects like ours and try to replicate them, but they almost never allow
for the flexibility the artist needs: they misunderstand us and leave us out...commissioning
more decorative work, with no contact with community people.... What made it really work
is the artists and the organizations [like ours] that came from the grassroots.

For community artists, there has been some serendipitous benefit—an ironic sort of coattails effect, considering that it results from art world denizens borrowing community artists' own methods—in the art world's recent interest in participatory or collaborative approaches to art making. But market-driven art thrives on novelty. It is likely that the art world will take another turn and noncollaborative modes of painting, sculpture and playwriting will once again occupy the anointed cutting edge. When it does, community artists will continue to assert that their work constitutes a valid, meaningful alternative life for the artist. But some of those who have persisted in community cultural-development work despite inadequate support admit that the effort of going against the grain takes a toll, as expressed by this community artist:

I'm trying to find ways to sustain my own will. Leadership is really fatiguing.

IT WOULD BE EASY TO CREATE A TYPOLOGY OF PRESTIGE ARTS PROJECTS

because they can be described in terms of end product: plays, ballets, symphony concerts, one-person exhibits and so on. But no really accurate and useful typology of community cultural-development work can be created; its crossing of arts-discipline boundaries, improvisatory nature, emphasis on process and impact in wider social arenas make for too many variables. Instead, such work should be understood as existing within a matrix of options such as the program models, themes and methods listed below.

Potentially, all of these are compatible. Any of the program models we describe might employ any of the themes and methods outlined. Each project employs a different constellation of such options shaped by the participants, their skills and aims, and the context of circumstances and issues in which they operate.

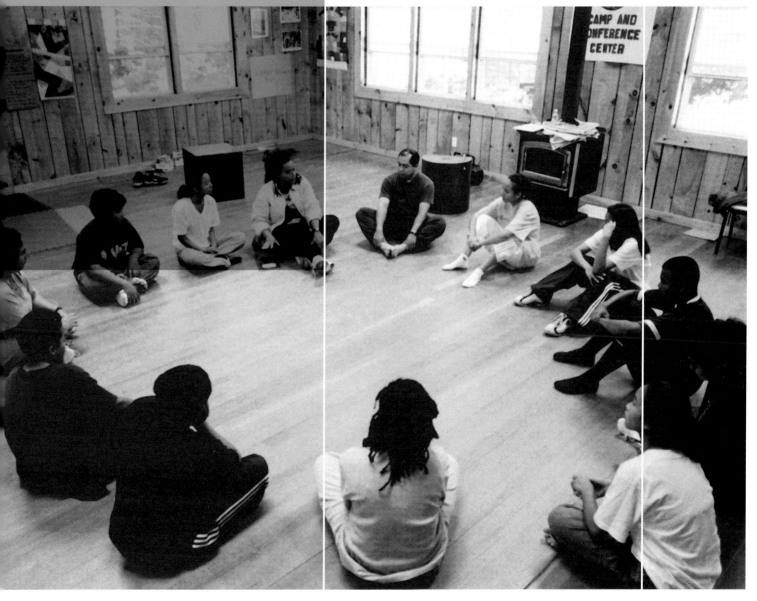

Many community cultural-development projects are built around learning experiences. Overall, the aim is to transmit particular arts-related skills while helping to develop critical thinking and establish a clear link between the two capabilities, thought leading to action.

For example, in its first year, the Rockefeller Foundation's PACT program[17] supported the San Francisco Mime Troupe in mounting storytelling and improvisation workshops for 120 high school students from diverse cultural backgrounds, with the immediate goal of creating a series of short plays based on their own experiences with race, class and immigration. The plays, by young

Performance from "Looking In/To The Future" summer workshop of New WORLD Theater in 1999. Photo © New WORLD Theater 1999

< New WORLD Theater Director Roberta Uno and guest artist Linda Parris-Bailey of Knoxville's Carpetbag Theatre lead a workshop for young people in western Massachusetts. Photo © Edward Cohen 1997

17 PACT stands for Partnerships Affirming Community Transformation. This publication arose from a study of PACT and the community cultural-development field it serves, carried out by the authors for the Rockefeller Foundation.

people from Horizons Unlimited, Girls Against Gang Violence, the Japanese Community Youth Council and the Columbia Park Boys and Girls Club, were worked into a 1996 production entitled *Gotta Getta Life*. In 1997 a second production entitled *Teen City* comprised five short plays on urban life by young people from the Columbia Park Boys and Girls Club, Girls Against Gang Violence, Horizons Unlimited, the Mission Recreation Center and the Upward Bound Program of the Japanese Community Center. "For me," said one teenaged participant, "the first Youth Festival was the start of a new future. It gave me a way to express my creativity to the whole world." (The Mime Troupe also received support from the Rockefeller Foundation's Multi-Arts Production [MAP] Fund in 1992, '94 and '96.)

Similarly, the first of two PACT grants to the New WORLD Theater at the University of Massachusetts supported its "Looking In/To The Future" project in 1996, bringing young Latinos and Southeast Asians from western Massachusetts together to learn about theater as a means of exploring their own cultural identities and confronting the challenge of cross-cultural communication. As the project has continued over several years, 80 young people between the ages of 7 and 18 have engaged in conflict-resolution and mediation training, explored cross-cultural differences and commonalities and exchanged artistic skills with each other and visiting performing artist-teachers. The collaborating organizations (Teen Resource Project's New Visions of Holyoke; Hampshire County Action Committee's Khmer Folk and Classical Dance Troupe of Northampton; and the Center for Immigrant and Refugee Community Leadership and Empowerment's Vietnamese youth group of Springfield) learned to use theater as a medium for personal development and have created several theater pieces showcased in community settings. (The New WORLD Theater also received a grant from the Rockefeller Foundation's Festival Fund in 1997.)

Community-based cultural projects commonly begin with research. Sometimes participants start with their own experience, as in the two examples just mentioned. But community artists have devised other research approaches that are dynamic, interactive and open to wider community involvement. For instance, project participants are often armed with media equipment—cameras, audio and video recording gear, sometimes with colorful props and costumes or portable displays to attract attention—in order to gather observations and information from passers-by. Participatory action-research of this type ensures that community cultural-development projects are grounded in real community concerns.

DIALOGUES

When communities are split over contentious issues, the aim of community cultural-development projects is often to create opportunities for dialogue rather than the type of debate that leads to greater polarization. Many different arts media can be used to articulate opposing views in ways that feel fair to the contending parties. Not every conflict has a win-win solution; interests are sometimes genuinely irreconcilable, and someone must prevail. But if compromise solutions can be found, dialogue that avoids objectification and posturing is essential as a means to that end.

For example, PACT provided grants in 1995, 1997 and 1998 to Appalshop to support its community radio station WMMT in sponsoring community forums and broadcasts on forestry policy in Appalachia, including the views of government, business and environmental groups in an effort to build a broad-based community consensus. WMMT's "Forestry Field Days" demonstrated alternative styles of logging, explored Appalachia's old growth at High Knob in the Jefferson National Forest, and confronted the devastation wrought by clear-cutting. Wide-open public discussion and education about these issues led to practical proposals for action.[18]

DOCUMENTATION AND DISTRIBUTION

Underlying much community cultural-development work is a desire to unearth realities that have been obscured by suppression, denial or shame. Many community cultural-development projects aim to create some sort of permanent record that can challenge the official story, whether in print, moving-image media or visual arts installation.

For instance, PACT funded three projects undertaken by Seattle's Wing Luke Asian Museum with the aim of bringing out the hidden histories of several local communities: Holly Park, a culturally diverse, 60-year-old housing project; Asian-Pacific veterans and war resisters; and the recent Southeast Asian immigrants who are changing the face of the Asian-American communities of the Pacific Northwest. Wing Luke received another PACT grant in 2000 to support "If These Hands Could Talk: Garment Workers in Seattle," an oral history and archival project culminating in a series of public programs and exhibitions recreating the first-person experience of Asian-Pacific American women garment workers. And in 1995 and 1996, the Alaska Humanities Forum received PACT grants for a three-year project, "Communities of Memory," collecting and presenting stories of life in Alaska from diverse residents in communities throughout the state.

Community artists work with other community members to enliven and present such materials in every medium that can be imagined: in publications and exhibitions; in murals; in plays produced for theatrical and nontraditional settings; in documentary or narrative film and video programs; and, more recently, in computer multimedia.

CLAIMING PUBLIC SPACE

Members of marginalized communities lack public space for their cultural expressions. Speaking concretely, they seldom have institutions, facilities or amenities equal to those available to more prosperous neighborhoods or communities. In terms of virtual space, they are likely to lack access to communications media and therefore to any meaningful opportunity to balance the sensationally negative pictures of themselves pervading commercial mass media. Many community cultural-development projects take this as their starting point, aiming to improve the quality of local life by adding self-created amenities to their communities or by building visibility for their concerns.

18 See, Appalshop's Web site at <www.appalshop.org/cmi/pages/forestrymain.htm> for more of the story.

In 1997, PACT supported the "Community Building Through Art and Land Transformation Project" of the Philadelphia-based Village of Arts and Humanities, whereby local residents converted empty North Philadelphia lots into parks and gardens, then celebrated their achievements through a culminating multi-arts festival. The Village's immediate neighborhood includes nine parks and gardens and two alleyways featuring murals. Angel Alley includes nine powerful Ethiopian angel icons; Meditation Park was inspired by Chinese gardens, Islamic courtyards and west African architecture; the Vegetable Farm is the first step toward a community sustainable-agriculture project; and the Youth Construction Park, created with a group of young people, features a pair of majestic cement and mosaic lions guarding its front entrance. The Village received a 1994 MAP Fund grant and a 2000 PACT grant to support a three-year program of assisting groups from three adjacent neighborhoods in their own building projects.

The Labor/Community Strategy Center in Los Angeles received PACT support in 1998 for its "Make History" project, an adjunct to the "Billions for Buses" civil rights campaign, which created public cultural space on wheels. The Bus Riders Union, which had won the right to represent users of public transportation in pressing for improvements to Los Angeles' inadequate system, collaborated with Cornerstone Theater to create theatrical improvisations and other arts elements of its on-the-bus organizing campaign, bringing tremendous attention to the problems of bus riders, a community previously largely invisible in a city so dominated and shaped by private transportation. Recurring characters include *Superpasajera* (Superpassenger), Defender of the Transit Dependent, and Dolores, a bride in full white-lace wedding regalia, the heroine of "Dolores' Dilemma," a bridal tale enacted on buses. (The Center also received a Rockefeller Foundation grant in 1998 as part of its "Conversations on Race" initiative.)

RESIDENCIES

Long-term community residency models such as the "town artist" approach (discussed in Chapter Four, Historical and Theoretical Underpinnings) have evolved abroad, where public agencies have seen community cultural-development projects as a legitimate, effective way of advancing their educational and organizing aims. For instance, the town artist concept came into being to assist residents of purpose-built new towns in post-War Europe to put their stamp on otherwise anonymous structures and public spaces, making them their own.

Because the United States has seen no equivalent of a local development authority willing to subsidize long-term, open-ended, artist-community relationships, United States residencies tend to be briefer, more narrowly focused and more outcome-oriented. A typical residency project in the United States would link an artist with a school for a single term or less or subsidize an artist or company to work for a few days, weeks or sometimes months with the clientele of a particular institution (e.g., a senior center) to create a specified product (e.g., a mural), rather than provide for development of ongoing, open-ended, collaborative relationships between artists and other community members.

None of the projects funded to date through PACT have centered on a long-term residency per se, but several have been able to achieve some elements of this model through persistence, careful planning and creative fund-raising. The Center for Arts Criticism, for instance, used 1997 PACT support and grants from other sources to build on five years of collaborations between Twin Cities artists and women from the Leech Lake Reservation in rural north-central Minnesota. Visiting artists worked regularly with a score of young women aged 12 to 20 in a project called "Sisters in Leadership," focusing on issues of racism, culture and economics on the reservation. Some of the photographs they made—powerful, sophisticated work including complex montages and manipulated images—can be seen at <http://thecircleonline.org/12.99/12.99.html>.

One artist involved in such open-ended community work explained to us how funders' lack of commitment to long-term work has put a brake on possibility:

> We know we have a long-term commitment to a community, but we have to say to local people just how far we're able to commit...If we made a longer-term commitment and the funds broke down, it would be counterproductive.

THEMES AND METHODS > HISTORY

Official histories reliably leave out many of the most resonant truths of marginalized communities—the reminders that sustain pride and hope. When such things pass from living memory, they deplete the stock of images and ideas from which an imagination of the future is constructed. As John Berger has put it,

> The past is never there waiting to be discovered, to be recognized for exactly what it is. History always constitutes the relation between a present and its past. Consequently fear of the present leads to a mystification of the past. The past is not for living in; it is a well of conclusions from which we draw in order to act.[19]

A strong through line in community cultural-development practice has been to add to the official record by sharing first-person testimonies and artifacts of ordinary lives.

Oral histories have formed the basis for countless plays, publications, murals and media productions. The impact of such projects is described by this director of a PACT-funded organization:

> Oral history: now that's really relationship building. It brings the generations together. [An oral history project] was the most amazing project I've worked with. A young person, in their twenties, fresh out of college, interested in the kind of work we're doing, had a group of kids [to train and supervise for project work]: some who'd been hanging out here, flipping rubber bands and not doing much. I saw these kids really change. We gave them pads, tape recorders, cameras and sent them out to gather stories from people in [the neighborhood]. Turned out most of them were from there, though we didn't realize it before. In a very short period, we saw them changed, transformed—from hangers-out to producers of a book, an exhibit, performances... Now I'll be talking with them about their goals

19 John Berger, *Ways of Seeing* (New York: Penguin, 1972), p. 11.

and ambitions and they'll say, "Maybe I should get into theater," or museum work or "Could
I write a book?" And you must understand these are kids who are struggling with their
adjustment to this country, as well as young people, trying to figure out what they can do.

In another example, PACT in 1996 supported the "Healing Heart Totem Pole Project," a video documenting how a bereaved father in the community of Craig, Alaska, mobilized friends and strangers to create and erect a totem pole in memory of his son who had died from a drug overdose—part of an epidemic of such deaths affecting Alaska native peoples. As friends and neighbors tell their own stories on tape, a picture takes shape of the pressures that lead to such tragedies and the power of culture to heal such pain.

Similarly, rescuing folktales and other storytelling traditions from obscurity has been a way to assert cultural continuity and use the wisdom of heritage to inform choices about how to move forward. Describing her own inspiration to enter the cultural development field, one of our interviewees credited

My abuelitas—grandmothers, great grandmothers—my father...They've shared their singing
and dancing and stories...Our sharing of our stories, telling about our joys and fears,
telling of how we survive, who we love, how we hate, how we deal with attacks towards
our lives, how we celebrate—todos estos cuentos are the secret of our survival as
gente...We need to tell the real story of our people and rid ourselves of the negative stereo-
types. All our lives, through television, newspapers, radio, movies, songs and stories,
we've been told that...our community is lazy, dumb and smelly...What we don't hear is the
truth and the only way to hear the truth is for each of us to be able to tell our stories. By
telling our stories, we challenge stereotypes.

IDENTITY

As wielded by mass media in the United States, cultural identity is a blunt instrument, with two main categories—"white middle-class" and "other." Very often, community cultural-development projects are predicated on a kind of reclamation work, with participants discovering and claiming their own ethnic and class identities as a way to recast themselves as makers of history rather than its passive objects. Grounded in the particularities of identity, individuals and communities can meet as equals—different and yet the same.

For example, PACT supported the Rhode Island Black Heritage Society in 1996 in bringing together immigrant communities from Cape Verde, Trinidad and Tobago, Liberia and Nigeria to share traditional dance, music, theater and food as a means of promoting cooperation between fragmented black communities. Many PACT-supported projects have focused on issues of cultural identity, often attempting to bridge misunderstandings between specific cultural groups.

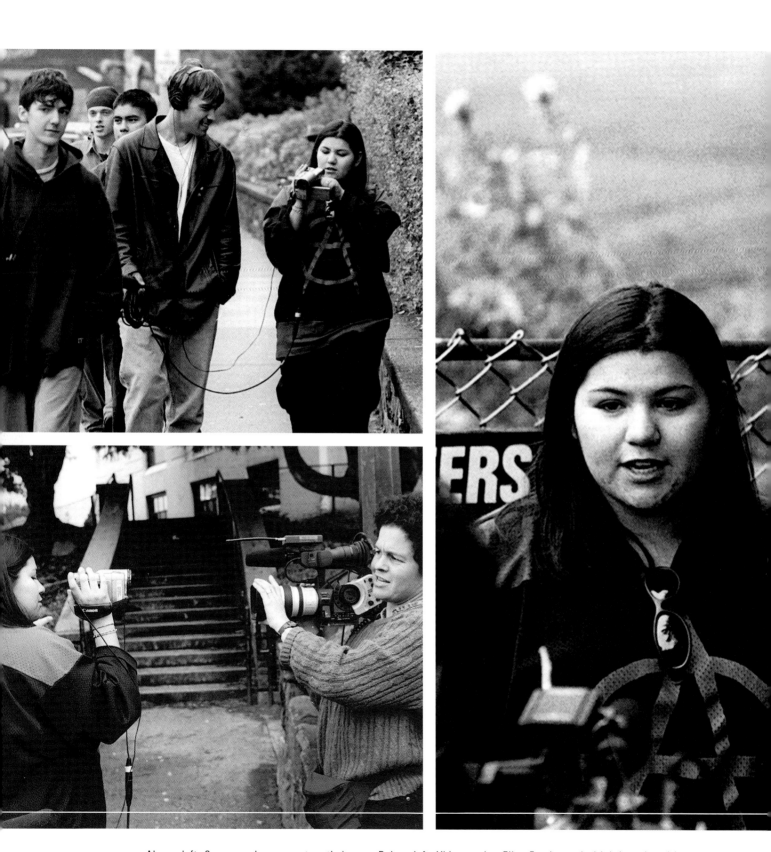

Above, left: Crew members go out on their own. Below, left: Videographer Ellen Frankenstein (right) works with high school students in Sitka, Alaska.

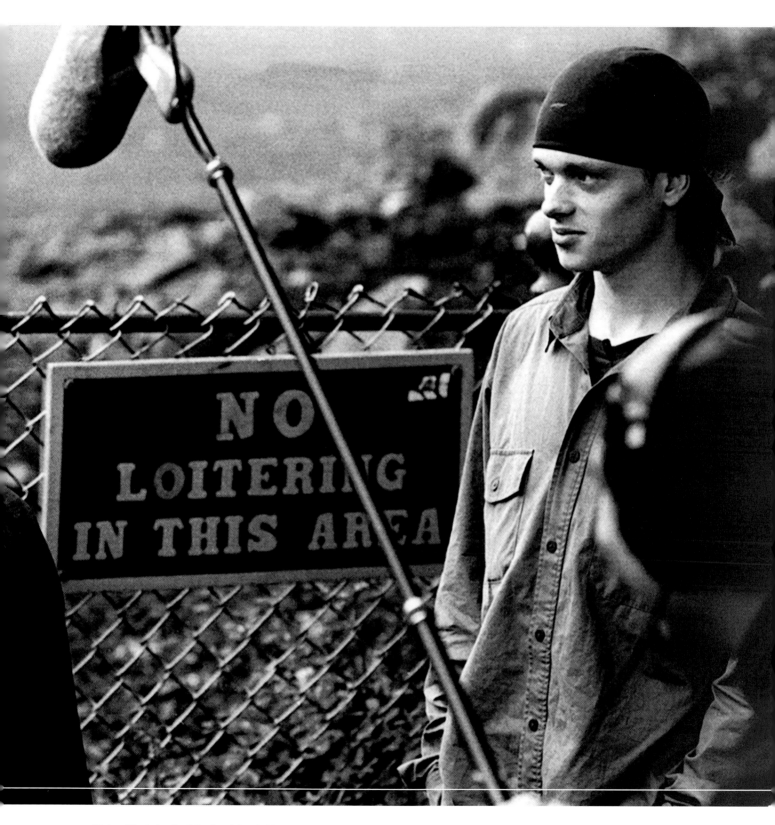

Right: "No Loitering" is the title of this production about young people's lives in Sitka, Alaska.

CULTURAL INFRASTRUCTURE

Marginalized communities lack cultural infrastructure as surely as they lack economic infrastructure. Just as economic development aims to stimulate the flow of capital and goods within a community and between it and other sources of prosperity, community cultural-development aims to stimulate the flow of cultural information and resources. One way this aim can be advanced is by training young people to deploy cultural tools for social change, asserting themselves as artists within their own communities and winning recognition for their contributions to cultural capital.

For example, in 1996, 1997 and 1998, PACT supported the East Bay Institute for Urban Arts' efforts to provide apprenticeship training for young people from low-income communities of color within Oakland, California, through its "Leaders in Community-based Cultural Work" project. Renamed CAAP (Careers in the Arts Apprenticeship Program), the ongoing program works in a combination of visual and performing arts media and takes on a different community issue each year. In 1998, CAAP participants learned about the United Nations Universal Declaration of Human Rights and became involved in local campaigns against police brutality and unjust policies in the high schools. In 1999, CAAP participants joined in efforts to unearth ancient creek beds, to hold local petroleum companies accountable for their air pollution and gain justice for families facing serious health problems due to environmental racism.

Esperanza Peace and Justice Center has used three years of PACT support (1995, 1997 and 1998) to sustain leadership training for adult members of minority cultural communities in San Antonio, drawing upon leading cultural activists from outside the community.

Another way to build cultural infrastructure is to link cultural development and economic development directly, creating outlets for cultural products produced by community members. Space One Eleven in Birmingham, Alabama, is launching the "City Center & Brick Co" project, contributing to the revitalization of the Central City/Metropolitan Gardens district by opening a retail storefront and promoting sales and commissions through the Internet. Art making and computer-based work with children and their parents have led to large public art commissions, development of community facilities, and a new income-generating business plan involving artists and other community members in creating decorative tiles, ceramics and cast-iron elements for architectural and landscape use. A major project has been a sculptural mural depicting a mythological industrial creature on the eastern facade of Birmingham's Boutwell Auditorium, comprising 15,000-20,000 glazed tiles made by children participating in the City Center Art Program.

ORGANIZING

In contrast to elite arts activity, which asserts the primacy of "art for art's sake," community cultural-development is undertaken in aid of the larger goals of social transformation and personal liberation. In some cases, arts activity provides a sort of lab or rehearsal for social action. Of such approaches, the best-known are the liberatory education practices of Paulo Freire and the related work of Augusto Boal in "theatre of the oppressed," discussed further in the next chapter, Historical and Theoretical Underpinnings.

For example, Youth for Social Change (YSC) in Durham, North Carolina, was supported by PACT in 1996 and 1998 in its ongoing efforts to build bridges of understanding between young people from Durham, North Carolina's deeply rooted African-American community and from its recently arrived Latino community. Focusing on issues of school reform, project organizers began using oral-history techniques to collect relevant stories from family members, then brought groups of young people together to talk about what was learned and to produce a play on educational issues. Against a back-drop of substantial violence between the two communities—assault, robbery, rape and even murder—YSC has been able to sustain and enlarge involvement in cultural activities designed to challenge stereotypes and build leadership through joint cultural projects.

COMMUNITY CULTURAL-DEVELOPMENT IS AN ART, NOT A SCIENCE.

The most skilled practitioners rely on qualities of sensitivity and intuition that cannot be quantified or standardized. Indeed, those who focus too closely on "models," "replicability" and "best practices" tend to produce dull work, lacking depth and heart. What Isaiah Berlin has written of political action also pertains here:

[T]heories, in this sense, are not appropriate as such in these situations.... The factors to be evaluated are in these cases too many and it is on skill in integrating them...that everything depends, whatever may be our creed or our purpose.... [T]heories no doubt do sometimes help, but they cannot be even a partial substitute for a perceptual gift, for a capacity for taking in the total pattern of a human situation, of the way in which things hang together—a talent to which, the finer, the more uncannily acute it is, the power of abstraction and analysis seems alien, if not positively hostile.[20]

20 Isaiah Berlin, "Political Judgment," *The Sense of Reality* (New York: Farrar, Straus and Giroux, 1996).

HISTORICAL AND
THEORETICAL
UNDERPINNINGS

Many historical and theoretical ingredients make up a mosaic of influences interacting with practice, helping to shape people's work and their thinking about it. It is true that the field has lacked adequate infrastructure to promote the development of theory, with a dearth of journals, training programs and forums for dialogue on practical, aesthetic and ethical issues. But we doubt that all the resources in the world would have produced a grand unified theory of community cultural-development. Given the nature of the work, this is as it must be and should be.

> *We should be looking at models with a small "m," so people can pick and choose and be aware of the values underpinning each one. There are constitutive elements people can extract from models. Large foundations often look for models with a capital "M"—things to replicate. I'm concerned that [they] not try to replicate models in this way.*

AN ACTIVISM OF IDEAS > Looking back over the history of community cultural-development, it is evident that community artists' vigor and influence gain strength when social activism awakens. We are accustomed to the notion that ideas have provenance. But it is also true, as a very depressed king wrote in Ecclesiastes a couple of thousand years ago, that there is nothing new under the sun. We could arguably begin our history with the cave painters of Lascaux who responded to the community's need for a record of significant events by tracing the shapes of animals on rock walls. But it seems most apt to take as a starting place the height of the Industrial Revolution, when industrialization, having given birth to urban anomie, also created its own opposition, expressed in nostalgia for a human-scale past.

THE SOCIAL INTEGRATION OF THE ARTIST

William Morris was the most famous 19th century exponent of a countervailing idea of the artist. According to the Romantic tradition that preceded Morris, artists are tortured geniuses who stand apart from social convention and ordinary concerns; they may suffer materially as a result of their indifference to such things, but even their suffering is exalted—Lord Byron's "spirit burning but unbent." The work of such artists must serve no practical function; it is pure embellishment, created for those with the exquisite sensibility (and generally the purse) to apprehend it. In contrast, Morris called for the social reintegration of the artist in a revival of artisanship, creating employment for skilled craftspeople capable of producing objects both useful and beautiful, filling lives with material harmony in defiance of the exploitative disharmonies of industrialism. In the April 1885 edition of *Commonweal*, Morris wrote:

> *[T]he chief source of art is man's pleasure in his daily necessary work, which expresses itself and is embodied in that work itself; nothing else can make the common surroundings of life beautiful and whenever they are beautiful it is a sign that men's work has pleasure in it, however they may suffer otherwise. It is the lack of this pleasure in daily work which has made our towns and habitations sordid and hideous, insults to the beauty of the earth which they disfigure.*

To fuel his visions, Morris dreamed of tempering the best of England's past with a democratic spirit, predicting a revival of art with the advent of socialism, which he saw as the only remedy for "The

< A veteran at St. Alban's VA Hospital in New York displays a collage depicting stories from his life, created through Elders Share the Arts' "Legacy Artworks" project. Photo © C. Bangs 1996

advance of the industrial army under its 'captains of industry'... [which] is traced, like the advance of other armies, in the ruin of the peace and loveliness of earth's surface."

As bourgeois society's complacency thickened and spread, it grew confining to those who longed more for passion and deep meaning than for mere comfort. One ironic consequence was a powerful attraction to the art of cultures which colonialism had aggressively submerged—the craze for "orientalism," the dream of total integration of art and life in romanticized imaginations of "primitive" societies. This enchantment persists: who has not heard the constantly repeated assertion, "In Bali, there is no word for art; everything they do is art"? The Romantic idea of the artist also persists—the inflated art markets of the '80s would have been impossible without it. But so does the conviction that there is a higher and more socially useful role for the artist than to decorate the surroundings of wealth.

This is one of the foundation stones of the community cultural-development field and has been a constant theme within the field. In 1982, as co-directors of the Neighborhood Arts Programs National Organizing Committee (NAPNOC), we convened a national conference of community artists in Omaha. Among the participants were now-recognized leaders in the community cultural-development field Liz Lerman and John O'Neal. We recorded their observations on this topic in *Cultural Democracy*, the newsletter we edited for NAPNOC. Here's how dancer/choreographer Liz Lerman described her own path out of conventional art dance into community cultural-development:

> *I believe dance historically was an incredibly major part of the people's lives. You danced and it would rain, you danced and your kids got better.... Take a look at what's happened to dance in most Western countries: what you find is a mirror of fragmentation.... You've robbed dance of its therapeutic qualities, its community, social qualities, all the things that dance is supposed to be doing for people.... I think my own need to experiment came...because this was a dead end.... My solution was to start working with people who are not trained dancers. That unleashing of their own creativity—it was so powerful and so beautiful that it would infuse any stage. And my job was to help them find and learn how to keep that moment....*

John O'Neal, who was then planning the "funeral" of the Student Nonviolent Coordinating Committee-affiliated Free Southern Theatre, spoke of the connection between cultural action and other forms of social action, recognizing

> *...a relationship of dependency of the artist on a vital social movement, because we don't exist in a void. The link, it seems to me, has to be some kind of organized political link between self-conscious, conscious artists working in some community and the structures that exist in that community for it to make decisions about what it's going to do.*

The search for a valued and integral social role for the artist continues, though still as an insurgent idea. Community artists propose and resource providers mostly dispose, although occasionally social institutions cooperate by providing the needed support.

THE SETTLEMENT HOUSE MOVEMENT

In many ways, the concept of culture began to cohere in American history in the late 19th century, when earlier generations of relatively prosperous immigrants from Western Europe and their descendants faced unprecedented waves of impoverished migrants from Ireland, Russia and Italy. Would the newcomers be successfully inducted into American culture or, as growing numbers of "America Firsters" charged, would they overwhelm and degrade that culture with unwashed foreign ideas and customs?

One coping mechanism was the establishment of settlement houses—community service, education and recreation centers in poor neighborhoods—of which the most famous was Jane Addams' Hull House in Chicago, begun in 1889. The underlying impulse was to integrate immigrants into what was put forward as the common culture, sometimes by providing health care and nutrition advice or wholesome recreations, sometimes by offering training that parents were unable to provide for their own children. (Kindergarten, an invention of the settlement houses, later became integral to public schooling.)

For their inventors, settlement houses' function of pulling immigrants into a dominant culture was a wholly good thing, a simple matter of equity, as Jane Addams stated it:

> The common stock of intellectual enjoyment should not be difficult of access because of the economic position of him who would approach it.[21]

The later critique of this impulse goes to the foundational concepts of community cultural-development: that real development consists in involving and drawing upon people's own cultures, not imposing middle-class culture. It is argued—rightly, we think—that in the world today, individuals are inevitably multicultured and social mobility derives in part from mastery of multiple cultural vocabularies. Still, in most social realms, mobility is limited if mastery does not encompass the signifiers of establishment culture.

In this respect, the settlement houses were a more complex phenomenon than they might at first appear: it was very often necessary that they adopt elements of language and culture characteristic of those they wished to instruct—Yiddish on the Lower East Side, Spanish in San Antonio—thus validating, even inadvertently, the concept of multiple belonging. Still, the primary aim was to inculcate middle-class values, rather than to aid communities in self-directed development.

Expressions of both impulses continue to coexist. Establishment arts institutions focus primarily on bringing new populations into contact with received culture, as by busing school groups to museums and offering lecture-performances on Western classical dance or music at schools and community organizations. Community cultural-development devotees focus much more on multidirectional cultural dialogue, as by working with immigrants to devise drama or photography projects depicting their own struggles with assimilation and difference in relation to mainstream culture—projects that may in turn be seen by audiences of nonimmigrants.

21 Jane Addams, *Twenty Years at Hull House* (New York: Macmillan, 1910).

POPULAR FRONT

In the mid-'30s, much of the American left adopted a strategy known as the "Popular Front," calling on activists to abandon their critical disdain for the values of mainstream culture and cease standing apart from it, instead involving themselves in every aspect of the larger society. With fascism on the rise in Europe, there was widespread feeling that artists must be part of this movement—that art should have social value, that it should in some way contribute to the struggle against totalitarianism and for democratic societies. To many artists, the Romantic idea of artist as emblem of alienation seemed tired and irrelevant. The painter Stuart Davis, opening the first American Artists' Congress in 1936 (as its secretary), expressed it this way:

> In order to withstand the severe shock of the crisis, artists have had to seek a new grip on reality. Around the pros and cons of "social content," a dominant issue in discussions of present day American art, we are witnessing determined efforts by artists to find a meaningful direction. Increasing expression of social problems of the day in the new American art makes it clear that in times such as we are living in, few artists can honestly remain aloof, wrapped up in studio problems.[22]

Later, the Red Scare of the '50s stigmatized activist artists, triggering a rapid retrenchment from this stance. One hypothesis is that abstract painting and its equivalents in other art forms were oblique expressions of dissent from Cold War America—that through abstraction, dissent went underground. Maybe so, but for all practical purposes, there was a radical discontinuity between the activist artists of the '30s and the generation of artist-organizers emerging in the '60s.

It would be difficult to demonstrate a direct line of inheritance from the Artists' Congress to the resurgence of activism 30 years later. But the general parallel in circumstances was certainly evident to young activists: consider the popularity during the '60s of the political art of Ben Shahn, an emblematic socially engaged artist and one of the signers of the "Call for The American Artists' Congress."

THE NEW DEAL

Franklin Delano Roosevelt's New Deal engendered employment and subsidy programs designed to put people back to work during the Great Depression of the '30s. From very early on, New Deal programs included arts initiatives. It is said that George Biddle, a signer of the American Artist's Congress call who had studied in Mexico with the painter Diego Rivera, put the idea of a publicly supported mural program into FDR's head. The first New Deal art initiative was the Public Works of Art Project, a section of the Civil Works Administration created to help ameliorate unemployment during the bitter winter of 1933-34 by commissioning murals for schools, orphanages, libraries, museums and other public buildings. By 1935, "Federal One" of the Works Progress Administration (WPA) was in full swing, with major divisions covering visual art, music, theater, writing and history.

22 From Davis's address "Why an American Artists' Congress?" delivered in New York in February 1936, as recorded in *Artists Against War and Fascism: Papers of the First American Artists' Congress*, edited by Matthew Baigell and Julia Williams (Rutgers University Press, 1986).

Holocaust survivors and immigrant grade school students mirror each other's movements in a performance >

at Elders Share the Arts' Living History Theater Festival in Flushing, Queens. Photo © Leroy Hendersen 1998

New Deal cultural programs began in response to massive unemployment—with the arts treated as a sector of the work force, like farm or factory labor—the primary aim being to give jobs to artists who could not hope to make a living in the private economy under prevailing conditions. That included writers such as Ralph Ellison and Richard Wright, painters such as Jackson Pollack and theater artists such as Burt Lancaster (who was then a circus performer).

But once so much talent had been harnessed to public purposes, visionary leaders such as Hallie Flanagan, head of the Federal Theatre Project (FTP), comprehended the potential for social change inherent in these programs. "In an age of terrific implications as to wealth and poverty," Flanagan

Mask work with western Massachusetts youth at part of "Looking In/To The Future" summer workshop of New WORLD Theater in 1996. Photo © Edward Cohen 1996

wrote, "as to the function of government, as to peace and war, as to the relation of the artist to all these forces, the theatre must grow up. The theatre must become conscious of the implications of the changing social order or the changing social order will ignore and rightly, the implications of the theatre."[23] To consider a single example, the FTP's "Living Newspaper" productions treated such controversial and urgent topics as poverty and exploitation (*One-Third of A Nation*) and the spread of syphilis (*Spirochete*) before they were closed down in 1939 by the House Committee to Investigate Un-American Activities, a harbinger of the anti-communist witchhunts to come.

Beginning in the '70s, young community artists manifested keen interest in the WPA. To cite examples from our own experience, the *Bicentennial Arts Biweekly* (a newsletter published as part of the countercultural "People's Bicentennial" in San Francisco, on whose editorial group Arlene served for a time) began with its second issue in November 1974 to feature stories on the New Deal for artists. The third issue included a memoir of WPA mural painter Robert McChesney, "to see what relevance those years might have for artists today." A later issue featured WPA muralist Bernard Zakheim, a signatory of the American Artist's Congress call. A centerpiece of the People's Theater Festival in September 1981 was a panel of veterans of the Federal Theatre Project. The January 1982 issue of *Cultural Democracy* was devoted to a survey of New Deal cultural programs on the 50th anniversary of FDR's election.

Community artists continue to be inspired by the New Deal today. It established the importance of oral history as a basis for cultural preservation; for instance, most of the surviving slave narratives available to us were collected during the WPA. It suggested the possibility of a permanent role for artists in community service. As Stuart Davis said at the time, "The artists of America do not look upon the art projects as a temporary stopgap measure, but see in them the beginning of a new and better day for art in this country."[24] This possibility was revived in the '70s with the advent of CETA (the Comprehensive Employment and Training Act, discussed later), the first public service employment program since the '30s to make extensive use of artists.

ARTS EXTENSION

Parallel to the development of the settlement house movement, American universities set up extension services, so called because they were intended to extend the educational and cultural resources of the university to the larger community. (The settlement house movement had itself been inspired by an academic initiative in Britain, begun as a campaign to encourage university students to settle in depressed communities and work there to improve living conditions.) Several university extensions pioneered the concept of arts extension. Perhaps the most notable was directed by Frederick Koch (who also served as a regional FTP director) in North Carolina. His North Carolina Playmakers, with its commitment to folk drama, was also supported by the Rockefeller Foundation.

But the longest-lived extension program was established in Wisconsin in 1907. Its most dynamic period began in 1945, when Robert Gard arrived to head up its theater program, which developed and produced plays about rural life in Wisconsin, held playwriting classes and contests, produced radio

23 Hallie Flanagan, *Arena* (New York: Duell, Sloan and Pearce, 1940), pp. 45-46.

24 Quoted in Richard D. McKinzie, *The New Deal for Artists* (Princeton University Press, 1973), p. 250.

plays, sponsored a playwright-in-residence program, carried out research and offered correspondence courses—among other initiatives aimed at developing a grassroots theater in the state. It eventually branched out to involve writers, music and art programs.

The animating idea behind the arts extension was contained in a letter graduate student Gard wrote to the Rockefeller Foundation in 1939, describing his aspirations:

> *I ponder more and more the question: in this great American growth of a non-commercial theatre...a theatre of the people...what will be the outcome, the goal? And increasingly it seems to me that the answer may be in the development of a...drama in which the...life of a community might be crystallized into dramatic form by those best able to do it: those who lived and [had] been a part of that legend and life.... The true "people's theatro," as I see it, will be the creation for the community of a drama in which the whole community may participate....*[25]

One of the insistent themes of domestic community cultural-development has been a critique of the urban domination of art making and a parallel assertion of the validity of rural forms, themes and styles. The ground for this conviction was laid in part by arts extension efforts from early to midcentury.

CIVIL RIGHTS AND IDENTITY POLITICS

"The '60s" is a commodious rubric, scooping a multitude of related phenomena into a single handy category. It conjures a period of cultural awakening during which marginalized groups embraced divergent identities and asserted their rights to recognition, liberty and a fair share of social goods.

During this period, cultural signifiers became a battleground. "Black is beautiful" is arguably the clearest possible use of aesthetic standards to symbolize a universe of oppressions and the struggle to overturn them. Underpinning civil rights slogans was a sophisticated discourse about cultural transmission of self-hating self-images.

The best known contributor to this analysis—and an acknowledged influence on activist-writers such as Malcolm X and Amiri Baraka—was Frantz Fanon, a psychiatrist born in Martinique who came to consciousness of his revolutionary ideas while practicing in Algeria during its struggle for independence from France. Focusing on the psychology of the colonized and colonizer, Fanon explored in depth the false consciousness created by colonizers and asserted the curative value of cleansing revolutionary violence against dominating powers. His discussion of the relationship of artists and intellectuals to popular liberation movements was deeply influential, especially to militant black activists, who easily extrapolated his colonial analysis to the experience of the descendants of slaves in the United States:

> *In the first phase, the native intellectual gives proof that he has assimilated the culture of the occupying power. His writings correspond point by point with those of his opposite numbers in the mother country.... This is the period of unqualified assimilation....*

25 Quoted in Maryo Gard Ewell's introduction to Robert Gard's *Grassroots Theater: A Search for Regional Arts in America* (University of Wisconsin Press, 1999), p. xviii.

In the second phase we find the native is disturbed; he decides to remember what he is.... But since the native is not a part of his people, since he only has exterior relations with his people, he is content to recall their life only. Past happenings of the bygone days of his childhood will be brought up out of the depths of his memory....

Finally in the third phase, which is called the fighting phase, the native, after having tried to lose himself in the people and with the people, will on the contrary shake the people.... [H]e turns himself into an awakener of the people.... During this phase, a great many men and women who up till then would never have thought of producing a literary work...feel the need to speak to their nation, to compose the sentence which expresses the heart of the people and to become the mouthpiece of a new reality in action.[26]

A central focus of a great deal of community cultural-development work is interrogating the social formation of identity, liberating participants' self-identity from imposed notions. People of color, women, gays and lesbians, rural people and other marginalized groups are the primary participants in this work. Fanon's revolutionary formulations continue to resonate. Along with several extensive quotations from Fanon, this excerpt from the writings of Kenyan exile Ngugi Wa Thiong'o was quoted by Thabo Mbeki, President of the Republic of South Africa, in an August 2000 Oliver Tambo Lecture that attracted a great deal of inflammatory press attention:

The effect of [the] cultural bomb [dropped by imperialism] is to annihilate a people's belief in their names, their languages, their environment, in their heritage of struggle, in their unity, in their capacities and ultimately in themselves. It makes them see their past as one wasteland of nonachievement and it makes them want to distance themselves from that wasteland. It makes them want to identify with that which is furthest removed from themselves; for instance, with other people's languages rather than their own....[27]

LIBERATING EDUCATION AND THEATER

Like Fanon, Brazilian educator Paulo Freire derived his theories from experience in the developing world—in Freire's case, through literacy campaigns with landless peasants in northeast Brazil in the years preceding his expulsion following the military coup of 1964. The theories and methods of Augusto Boal, a Brazilian theater director (who in recent years served in Rio de Janeiro's municipal legislature), were developed during the same period of the '50s and '60s and have much in common with Freire's. Freire's first book to be released in the United States was entitled *Pedagogy of the Oppressed*; Boal's was *Theatre of the Oppressed*.

The spine of Freire's work is that without the ability to read and write—to comprehend and interpret the modern world—individuals become objects of others' will, rather than subjects of their own history. Internalizing their oppressors' views of their own identity and capabilities—having taken as their own these extremely reductive and disabling notions of their value as human beings—they become passive

26 Frantz Fanon, *The Wretched of the Earth* (New York: Grove Press, 1963), pp. 222-223.

27 Ngugi Wa Thiong'o, *Decolonising the Mind* (London: James Currey, 1986), p. 3.

objects of a world whose workings seem mysterious and incomprehensible. Indeed, they may experience a disabling "fear of freedom" that prevents their even trying to reach beyond such imposed self-definitions.

By engaging in dialogue stimulated by "generative themes" (pregnant images or concepts of great moment to those discussing them), participants comprehend their real relationships to these themes, experiencing the power of language and their own power to shape culture through its use. Instead of seeing literacy training as a scheme foisted upon them by authorities for reasons having nothing to do with their lives, they come to understand that learning to read empowers one to decode the world and to act within it.

This "transformation of consciousness" from "magic thinking" (seeing reality as the product of baffling and hidden processes beyond one's control) to "critical consciousness" (being able to comprehend and enter into the process of shaping reality) is the primary goal of Freire's approach to education, usually referred to as "liberating education" or "critical pedagogy."

While much of Freire's attention focused on the transformation of individual consciousness and small-scale group work, his ideas also have larger relevance. As he wrote in *Pedagogy of the Oppressed*, every epoch is characterized by "a complex of ideas, concepts, hopes, doubts, values and challenges in dialectical interaction with their opposites...."[28] That each epoch generates such a "thematic universe" is an extremely useful insight for those who wish to understand why our own era is pulled in so many directions by force of faith and reason, of imposed versus self-led development, of cultural diversity and cultural privilege. Freire's work suggests that it is the interaction of themes in and of itself that ought to command our attention. None of us can confidently say that any element of our thematic universe should be regarded as the foreground, relegating the rest to background noise.

International associations, conferences, academic specializations, and scores of interpretive books and courses have sprung up around Freire's ideas, as well as nonacademic networks for people who work with farmworkers, for instance, or immigrant communities. They have also spread far beyond the field of literacy education, greatly influencing adult and popular education programs and cultural organizing in the United States and abroad.

In organizing contexts, one of Freire's most powerful concepts is "internalization of the oppressor," the process whereby individuals and communities are subliminally persuaded to worldviews and self-images that serve interests counter to their own. Social movements of the '60s, for example, focused on recognizing and rooting out invidious self-concepts such as the idea that women are less capable than men or that European images of beauty are superior to all others. Similarly, a common element of community cultural-development projects is to focus on the gulf between the way one's community is regarded and portrayed in "mainstream" culture and the way it comes across in uncoerced self-portraiture.

Boal's work also turns on dialogue—a free exchange between equals—which he considers the ideal human experience. Using the language of theater to comment both on dramatic work and on the larger world, he asserts that oppression occurs when dialogue becomes monologue:

28 Paulo Freire, *Pedagogy of the Oppressed* (New York: Continuum, 1982), pp. 91-92.

[T]he ruling classes took possession of the theater and built their dividing walls. First, they divided the people, separating actors from spectators: people who act and people who watch—the party is over! Secondly, among the actors, they separated the protagonists from the mass. The coercive indoctrination began!

Now the oppressed people are liberated themselves and, once more, are making the theatre their own. The walls must be torn down. First, the spectator starts acting again: invisible theatre, forum theatre, image theatre, etc. Secondly, it is necessary to eliminate the private property of the characters by the individual actors: the "Joker" System.[29]

Of all Boal's approaches, "forum theatre" has probably had the widest influence on community cultural-development work. This method involves setting up situations in which actors are not divided from spectators; rather, all are "spectactors," able to cross the invisible "fourth wall" of the theater and enter the action. Together they share stories of unresolved political or social problems. Then a smaller group of spectators devises a skit or scene (perhaps 10 minutes in length) encapsulating the salient elements of one or more stories, including a possible (but ultimately unsatisfactory) resolution and this is performed for the group. (For instance, a group of workers might enact the process of registering a grievance with management and when satisfaction is not forthcoming, staging a wildcat strike.) Then the "Joker," a kind of facilitator, asks members of the larger group to consider whether they are satisfied with the proposed resolution and if not, to imagine other points of intervention, other ways to proceed. The skit is then performed again, exactly as it was the first time; only now, any spectator may call a halt to the action and come onstage to replace the protagonist(s), taking the scene in a new direction (always remaining in character, taking part fully in the dramatic action). A group may choose to replay the scene from the beginning more than once, to allow a greater range of scenarios to be attempted. At the end, the process may be discussed by all; or it may be that the enactment itself suffices.

This approach has been used to great effect in the developing world, for example, with *harijan* communities in India, as a way to plan social action with groups of people who are not in the habit of attending meetings. It has also become much more visible in the United States in the past decade, as Boal has worked with several groups in the States to start branches of the Center for the Theatre of the Oppressed.

If asked to name the most powerful international influence on community cultural-development practice, we would choose the interrelated work of Freire and Boal. Freire's name was mentioned most often when we asked our interviewees for this study to enumerate their own influences. Boal's name came up with the majority of theater people and was mentioned by others involved in community organizing.

CETA AND PUBLIC SERVICE EMPLOYMENT

The Comprehensive Employment and Training Act (CETA) has come to be used as shorthand for a whole constellation of public service employment programs created by the Nixon and Ford administrations during times of high unemployment in the mid-'70s. CETA was ended almost overnight when Ronald Reagan took office; but at its height in Fiscal Year 1979, the Department of Labor estimated

29 Augusto Boal, *Theatre of the Oppressed* (New York: Urizen Books, 1979), p. 119.

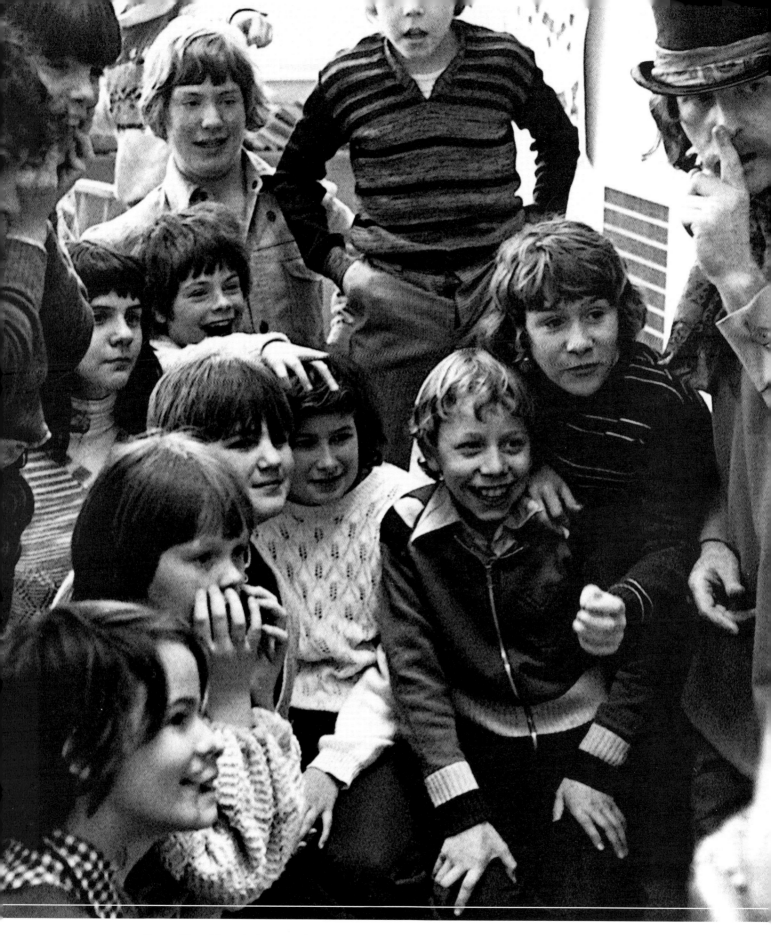

George King of Inter-Action, one of the first British community arts projects, working with a group of special needs children in Milton Keynes, 1975.

that $200 million had been invested in CETA arts jobs in that year alone. CETA was demonized by Reagan-era politicians as a pork-barrel program; the same rhetoric that would later be deployed to condemn putative "welfare queens" was used to evoke the specter of taxpayer-subsidized employees goofing off in painting and theater workshops while having the temerity to call it work. But to community artists, it was indeed work and it was a tremendous boon.

Thanks to a fortuitous combination of personalities and circumstances, San Francisco was one of the first places CETA arts jobs took off. John Kreidler, now director of Cultural Initiatives Silicon Valley, worked during the Nixon administration for the U.S. Office of Management and Budget (OMB) where he was responsible for a portfolio of Federal programs involving youth employment and occupational health. He took his OMB-derived knowledge to the San Francisco Neighborhood Arts Program and turned it into jobs for community artists.

For instance, the *Bicentennial Arts Biweekly* of December 18, 1974, featured an article describing "a queue of 300 unemployed artists—each hoping to get one of 24 new art positions recently made available by the Emergency Employment Act" (a CETA forerunner). An article in the January 9, 1975, edition began, "Unemployed artists are being hired with federal funds in San Francisco in a program reminiscent of the WPA during the '30s Depression." At that time, 23 artists had just begun work at the San Francisco Art Commission's Neighborhood Arts Program and the de Young Museum Art School at the princely sum of $600 a month. Due to open any day were applications for 90 additional jobs for muralists to work in schools and housing projects, performing artists to fill residencies with community organizations and writers to work on oral histories of San Francisco's neighborhoods. By June of 1977, many CETA-funded artists were employed not just by city agencies and institutions, but through private nonprofit organizations. The June 1, 1977, issue of the *Bicentennial Arts Biweekly* notes that 899 proposals had been made by nonprofits to make use of the 1,500 CETA jobs then available to nongovernmental organizations and that many were from arts and community organizations.

There is scarcely a community artist who was around in the mid-'70s who did not either hold a CETA job or work directly with someone who did. Most community-based groups in the United States dating from that time were launched on their labor-intensive path with CETA support. The way many community artists speak about the experience evokes Stuart Davis's comments on the WPA: that the public employment of artists was a foretaste of a "new and better day for art in this country." But it's off the menu now.

PEOPLE'S HISTORY AND ANTHROPOLOGY

Certain techniques current within the community cultural-development field, such as oral history, are in use in multiple realms. A huge body of oral-history material has been created and put to diverse uses by historians, anthropologists and community artists. They have included WPA workers collecting slave narratives or tramping through cotton fields to record traditional blues with commentary in the singers' own words; "radical history" projects of the '60s and '70s, preserving the life stories of

activists from a previous generation; and pioneering anthropologists like Barbara Myerhoff, whose work with elders demonstrated the power of telling one's own story.[30]

Community artists have been resourceful in mining other fields for useful material without necessarily adopting the particular standards, styles and approaches of those specializations. As artists, for example, they generally feel free to rummage through oral-history collections, selecting and juxtaposing snippets of text. Such a patchwork approach to composition often yields powerful composite portraits (while sometimes setting orthodox academic historians' teeth on edge).

An equivalent use of visual imagery can be seen in "The Great Wall of Los Angeles," a mural over a half mile in length created on the walls of the Tujunga Flood Control Channel in the San Fernando Valley near Los Angeles. Begun in 1974 by Judith Baca, founder of the Social and Public Art Resouroc Center (SPARC), existing sections portray an ethnic peoples' history of California from prehistoric times to the 1950s. Recently, SPARC received a 2000 PACT grant to facilitate a civic dialogue designed to yield the next four decades of the "Great Wall," bringing the mural up to the 1990s.

No single scholar or academic specialty has been put forward as a key influence on the community cultural-development field, but many community artists have drawn inspiration from particular historians or anthropologists. This niche of the field is better networked than most others, thanks in part to its closer affinity to academic structures, museums and other cultural institutions which have provided modest underwriting. There are local, regional, national and international oral-history associations as well as dozens of archives and collections. Community artists may draw on all of this material, but there are no programs specifically intended to support their use of oral histories. This lack of financial and technical support limits the amount of community-based work going on today; but there is a positive sense of forward momentum among leading practitioners, an eagerness to move forward, not only in the United States but internationally.

> I see this work as a social movement. Some things can and should be done for the groups that are still around.... There's the community-based museum angle, community arts...an efflorescence of folklorists working with community groups. Both the NEA and NEH directors are folklorists right now. Politically that's important because the Right has been easily able to criticize the elitism of the NEA and [NE]H and they can't do so with folklorists. We need to consolidate the 20 or 30 years of work that's been going on and develop new approaches that are grounded in practice.

CULTURAL DEMOCRACY

International cultural policy discourse has had an indirect influence on community artists in the United States, through visiting artists and scholars as well as publications and organizing initiatives. The most influential idea has been "cultural democracy"—the major postwar innovation in international cultural-policy thinking.

30 See, Barbara Myerhoff, *Number Our Days: Culture and Community Among Elderly Jews in an American Ghetto* (New York: Meridian, 1994), originally published in 1979.

In the period following World War II, European cultural authorities, responsible to an expanding public as their nations rebuilt and continued to industrialize and urbanize, experimented with methods of "democratizing" elite culture, such as busing schoolchildren to symphony concerts, subsidizing theater tickets, staging art exhibits in local community centers and mounting huge "blockbuster" exhibits with massive promotional campaigns intended to draw new audiences. After sustained investment in this approach, it was found to be largely a failure:

> *In theatre, for example, thanks to price reductions resulting from subsidies running as high as three quarters of real cost, access has become possible for those whose cultural background already gave them the desire and the need to come. But the general public still stays away.*[31]

In response to this failed strategy of "democratizing high culture," cultural ministers refocused their attention on "cultural democracy" in the early '70s and it became the main watchword in international discourse until the mid-'80s.

Cultural democracy is predicated on the idea that diverse cultures should be treated as essentially equal in our multicultural societies. Within this framework, cultural development becomes a process of assisting communities and individuals to learn, express and communicate in multiple directions, not merely from the top—the elite institutions of the dominant culture—down.

The theory is promising, but for fairly obvious political reasons, most practical applications have been halfhearted. Although Europe's greatest need for cultural development in the post-World War II period existed in previously marginalized communities, the cultural ministers' practice fell far short of fulfilling this need. Cultural ministries' budgets instead reflected a continuing perception of prestige institutions as their primary "clientele." Nevertheless, most European cultural authorities also undertook to support community cultural-development efforts, experimenting with various approaches to *animation socio-culturelle*.

At the same time, decolonization in the developing world was presenting cultural authorities there with a related dilemma: how to de-emphasize culture deriving from colonizing powers in favor of indigenous development. Experimental efforts here also focused on new roles for *animateurs* and other cultural-development workers, as well as on development of basic cultural infrastructure and on creative uses of culture to support community development. Third World practitioners led the way in adapting cultural forms to the tasks of exploring issues, identifying options and mobilizing action around such basic problems as water, women's rights, unemployment and agricultural development.

American community artists came into contact with this work mainly through individual exchanges. From our earliest days at the Neighborhood Arts Programs National Organizing Committee, we provided information on international resources for community artists (the second issue of the newsletter carried a review of UNESCO publications), as well as a contact point for international visitors whose inquiries about cultural policy drew only uncomprehending stares at the National Endowment for the Arts.

31 Augustin Girard with Geneviève Gentil, *Cultural Development: Experiences and Policies*, Sec. Ed. (Paris: UNESCO, 1983), p. 66.

For instance, in the October 1980 NAPNOC newsletter, John Pitman Weber, director of the Chicago Mural Group, described a visit to Europe in which he encountered a range of community cultural-development initiatives not widely known in the United States, including the "town artist":

> More than a long-term residency, the town artist is an integral part of a new town's planning/building team. The town artist is most often a trained sculptor. He has his own workshop and team, including apprentices (a postgraduate position). The town-artist team provides permanent media artwork including landmark sculptures for housing and shopping areas, social seating sculptures and play sculptures and cast architectural ornament for housing, underpasses, painted murals and special paving designs. The town artist often facilitates participatory projects by residents, e.g., a recent mosaic underpass in Glenrothes, Fife, by children, led by a member of the arts team.

In December 1980, the newsletter featured an article based on an interview with Jacob Sou, director of the Regional Cultural Action Center (RCAC) in Lomé, Togo, then visiting the United States to explore an African-American theater exchange at the request of members of Alternate ROOTS (the Regional Organization of Theaters South, a still-active association of community-based theater companies and performing artists that received a 2000 PACT grant to support a program of training by and for community artists). In this passage, his description of how RCAC's program was in part shaped by the legacy of colonization is followed by our summary of the approach:

> "I didn't study African history in school. I studied French history and because it wasn't my country, I couldn't keep it…. I don't know that much about African history—I have [had] to learn it, after school. So we try to teach people 'What is Africa?' 'What are African customs?' and generally, they are just learning it for the first time." Since each animateur's work will center on reawakening active interest in African cultural forms, this attention to African traditions, economics, social life and politics continues throughout the training period and serves not only to educate the students themselves, but to prepare them to involve other community members in the same process of recovering cultural traditions and creating new African cultural activities.

By the time of NAPNOC's annual conference in Omaha in 1982, it had become a priority to keep up an active international exchange. A centerpiece of the conference was a presentation by Andrew Duncan, a founding member of London's Free Form Arts Trust, an offshoot of Inter-Action, one of the first British community arts organizations. He described a range of project models that had considerable influence on his American listeners: planning projects that used video and community events to help residents of a housing estate organize themselves to press for community use of derelict facilities; making a slide/tape with developmentally disabled young people, based on Polaroid snapshots and snatches of ambient sound they'd "collected" walking through their own neighborhood with cassette recorders; and creating huge fire-shows comprising a community procession and a performance climaxing in a bonfire in which symbolic structures of oppression were constructed, then burned.

Political change has affected European groups doing this sort of community cultural-development work. In the '70s and '80s, they received reliable general operating support from public arts agencies and local governments, leaving them free to pick projects on the basis of community interest. But the past decade's trend toward privatization has led to lower levels of general support and to more ear-marked, project-oriented funding from a variety of sources—for those groups that have been able to survive. Most of these funding sources are still public. A project that touches on HIV prevention, for instance, might receive a local health authority grant, a European Union grant and support from local educational authorities.

In contrast, public support for such work in the post-Reagan United States is minuscule and private funds for community arts don't approach the level of support available in other countries. So even with the reduced circumstances prevailing abroad, connecting with foreign community artists has kept alive for their U.S. counterparts an enticing vision of what could be, if only resources permitted.

Whenever possible, community cultural-development practitioners in the United States have eagerly engaged in exchanges and collaborations with their counterparts abroad. For example, the San Francisco Mime Troupe has received Multi-Arts Production (MAP) Fund support from the Rockefeller Foundation for Pacific Rim collaborations with Hong Kong-based artists and with the Philippines Educational Theatre Association (PETA), a leading practitioner of people's theater, born in the mid-'60s when resistance to the Marcos regime was just beginning. Western Pennsylvania's Bloomsburg Theatre Ensemble similarly received MAP funding for a collaboration with Nana Mthimkhulu from South Africa, Zanji Njovu from Zambia and Ignatio Chiyaka from Zimbabwe.

SO FAR AS WE ARE AWARE, THERE HAS BEEN NO ATTEMPT BY PRACTITIONERS IN THE UNITED STATES TO FORMALIZE A THEORY OF COMMUNITY CULTURAL-DEVELOPMENT.

People rightly insist that their ideas about the work emerge from practical experience, which might be distorted by the imposition of such a framework. A few groups have developed formalized methodologies, but these focus on practical steps in approaching projects, rather than principles, values or informing ideas.

THEORY FROM PRACTICE: ELEMENTS OF A THEORY OF COMMUNITY CULTURAL-DEVELOPMENT

For example, the PACT-funded East Bay Institute for Urban Arts in Oakland, California, puts forward "CRAFT [Contact, Research, Action, Follow-up and Teaching], a methodological model through which the creative arts become understood as important resources to community-based organizations"[32]; and New WORLD Theater of Amherst, Massachusetts, makes a practice of extensively documenting all the workshop processes it has undertaken on its own and with visiting artists. A few groups have become

A musical interlude from Cornerstone Theater's community-based production: "Broken Hearts: a B.H. Mystery." Photo by Lynn Jeffries, © Cornerstone Theater 1999

< Artworkers assemble at the Tujunga Flood Control Channel in Van Nuys, California, to help create the Social & Public Art Resource Center's Great Wall mural. Photo © SPARC 1976, 1983

32 "Out of the Box: The Urban Arts Approach," a brochure produced by the East Bay Institute for Urban Arts, Oakland.

recognized as leaders in specialized areas of work and have advanced theoretical frameworks as well as methodologies in their areas of specific focus, such as New York's Elders Share the Arts (ESTA), which published *Generating Community: Intergenerational Partnerships through the Expressive Arts*[33] and is frequently called upon to train other agencies to do similar work. (ESTA received a 2000 PACT grant for a project entitled, "Crossing the Boulevard: Stories, Sounds and Images of New Immigrants," focusing on the borough of Queens, New York.)

Based on our synthesis of community artists' own experience, we have sketched out the beginnings of a framework for understanding community cultural-development practice, as follows.

DEFINITIONS

In community cultural-development work, community artists, singly or in teams, place their artistic and organizing skills at the service of the emancipation and development of an identified community, be it one of proximity (e.g., a neighborhood or small town), interest (e.g., shipyard workers, victims of environmental racism) or any other affinity (e.g., Latino teenagers, the denizens of a senior center). While there is great potential for individual learning and development within the scope of this work, it is community focused, aimed at groups rather than individuals, so that issues affecting individuals are always considered in relation to group awareness and group interests.

In this context, "community" is understood as dynamic, always in the process of becoming, never static or complete. In a social climate of pervasive alienation, part of the community cultural-development practitioner's task is to help bring a consciousness of community—often, of multiple belonging—into being.

CORE PURPOSES

Community cultural-development work is predicated on the understanding that expression, mastery and communication through the arts powerfully encode cultural values, bringing deeper meanings of experience to the surface so they can be explored and acted upon. Community cultural-development work embodies a critical relationship to culture, through which participants come to awareness of their own power as culture makers and employ that power to solve problems and address issues of deep concern to themselves and their communities.

Community cultural-development work incorporates certain core beliefs about the nature of the social transformation it seeks to advance:

– Critical examination of cultural values can reveal ways in which oppressive messages have been internalized by members of marginalized communities. Comprehending this "internalization of the oppressor" is often the first step toward learning to speak one's own truth in one's authentic voice.

– Live, active social experience strengthens individuals' ability to participate in democratic discourse and community life, whereas an excess of passive, isolated experience disempowers.

33 Susan Perlstein and Jeff Bliss, *Generating Community: Intergenerational Partnerships through the Expressive Arts* (New York: ESTA, 1994).

– Society will always be improved by the expansion of dialogue and by the active participation of all communities and groups in exploring and resolving social issues.

– Self-determination is an essential requirement of the dignity and social participation of all communities. No narrow interest within society should have the power to shape social arrangements for all others.

– A goal of community cultural-development work is to expand liberty for all, so long as no community's definition of "liberty" impinges on the basic human rights of others.

– A goal of community cultural-development work is to promote equality of opportunity among groups and communities, helping to redress inequalities wherever they appear.

– Community cultural-development work helps create conditions in which the greatest number are able to discover their potentials and use their resources to advance these aims.

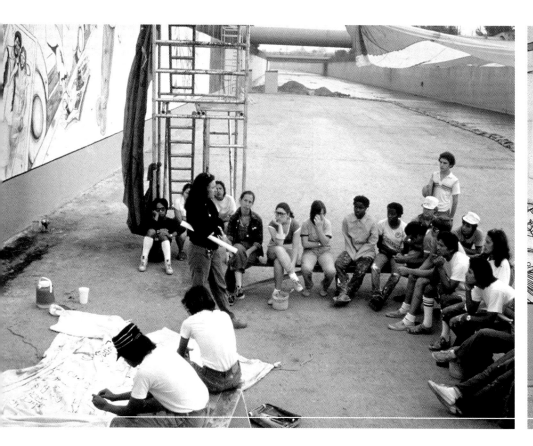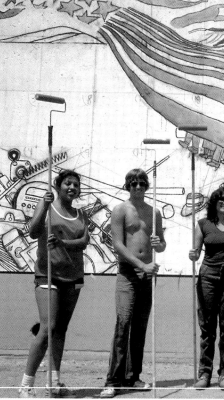

Left: SPARC founder Judy Baca with the Great Wall team in morning meetings. Center: Team members prepare >

Whenever and wherever they are deployed, community cultural-development initiatives are respon-sive to social and cultural conditions. In our era, many pressing social problems—racism, homophobia, conflicts over the nature of public education and conflicts over immigration, to pick just a few examples—are understood to be essentially cultural. Cultural responses are required to address them. Indeed, attempts to address them by means such as litigation and legislation have often fallen far short of the mark because they ignore the cultural dimension. Cultural values are transmitted and sustained by human beings in community, not by laws, edicts or court decisions, regardless of the power these may exert in other realms.

While some social characteristics are overarching, affecting all members of a society, others are particular to a region or community. Social conditions cannot be generalized: a county's overall demo-graphic makeup may obscure marked differences in the complexion of individual towns; and knowing a

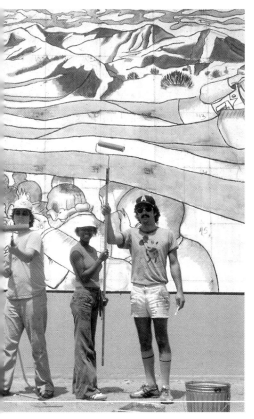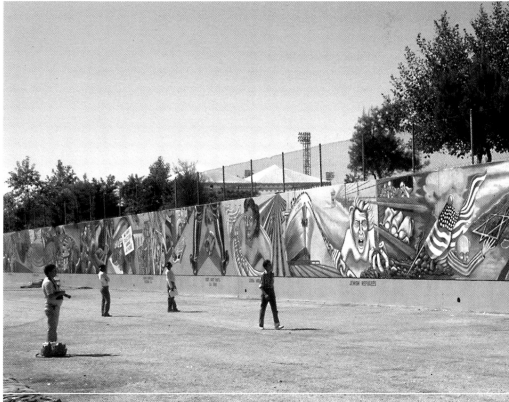

to add magenta glaze over blue line drawings. Right: Long shot of 1940's section. Photos © SPARC 1976, 1983

town's overall economic profile may not provide much useful information about conditions in a particular neighborhood. An essential feature of community cultural-development practice is participatory research into the life of the community, engaging participants in building a "thick description"[34] of their own cultural conditions and challenges which then serves as a basis for any future work.

CONFLICT

Conflict lies at the heart of community cultural-development work, though its ability to resolve conflicts is limited. Community cultural-development is grounded in reciprocity and authentic sharing. When parties in conflict are more or less equal in social power, community cultural-development methods can evoke and illuminate multiple coexisting realities, overcoming stereotyping, objectification and other polarizing habits of mind. Appreciation for valuable distinctions and deep commonalities can emerge from reciprocal communication through arts media, as participants begin to perceive common interests and possible compromises where they previously saw only intractable differences.

But where there is a pronounced imbalance in social power between conflicting parties, it may emerge that real, material interests cannot be reconciled. While members of a dominant group may come to appreciate the beauty of the culture of those they oppress, this will not necessarily lead them to moderate their own interests in favor of the oppressed. Practitioners must be aware of such imbalances and approach such situations with great caution, lest their efforts inadvertently lead to further discouragement and exploitation.

ARTIST'S ROLE

Organizing skills are crucial to community cultural-development, but the work cannot realize its full potential in the hands of organizers lacking artistic ability and understanding. Vibrant creativity, a wide cultural vocabulary, the capability of conveying information through imagery, sensitivity to subtle shadings of meaning, imaginative empathy, the craft to shape bits of social fabric into satisfying, complete experiences that cohere as works of art—these are the stock in trade of the skilled and committed artist. Without them, projects cannot rise beyond the level of well-intended social therapy or agitprop.

ARTS MEDIA AND APPROACHES

All artistic media and styles are amenable to community cultural-development use. Powerful projects have employed visual arts, architectural and landscape design, performing arts, storytelling, writing, video, film, audio and computer-based multimedia in many different combinations and approaches.

34 This phrase, now in wide usage, derives from anthropologist Clifford Geertz's essay "Thick Description: Toward an Interpretative Theory of Culture," *In The Interpretation of Cultures* (New York: Basic Books, 1973). In brief, Geertz calls for interpretation of signs that incorporates the full range of potential meanings, rather than applying to one culture the bias toward a particular meaning favored in another. He uses the example of the "wink of an eye," which may be a physical reflex, a secret code, a parody or joke and so on. In the context of community cultural-development, the aim is to use many sources and types of testimony and evidence to construct a multilayered, nuanced account of cultural life.

PROCESS VERSUS PRODUCT

Although projects may yield products of great skill and power (such as murals, videos, plays and dances), the process of awakening to cultural meanings and mastering cultural tools to express and communicate them is always primary.

To be most effective, projects must be open-ended, leaving the content and focus to be determined by participants. "Action-research"—whereby the direction of a project is focused through experimentation with different approaches to gathering relevant material, each producing new learning—is a key element of community cultural-development work. Social and cultural creativity are paramount. Freedom to experiment and even fail is essential to the process.

Attempts to make projects conform to predetermined models remove them from the category of authentic community cultural-development.

EXPRESSION VERSUS IMPOSITION

Community cultural-development projects draw on the cultural backgrounds and experiences of participants, which may be highly specific or richly multicultural, with many layered influences. If practitioners impose their own artistic or social agendas on participants or attempt to transfer the cultural values of other social groups to those with whom they work, they transgress the bounds of authentic community cultural-development, which is a nondirective practice, undertaken voluntarily and co-directed by participants and professional practitioners.

While projects often involve people from multiple cultural backgrounds, necessitating a sharing of contrasting meanings and expressions, such exchanges must always be grounded in genuine equality and reciprocity in order to aid in community cultural-development.

RESPONSIBILITY FOR PARTICIPANTS

Community cultural-development techniques often cross boundaries of intimacy, as when participants are asked to share elements of their life stories or their deepest feelings about the way a problem affects themselves and their communities. It is the practitioner's responsibility to ensure that participants are not coerced into a premature or unprotected intimacy, which can have disastrous effects on the individual and the group.

Trust must be earned gradually, violations of trust must be pointed out and corrected, and there must always be opportunities for individuals to opt out of situations they experience as intrusive or unsafe.

LEGAL CONTRACT VERSUS MORAL CONTRACT

It is in the nature of community cultural-development work that criticism of existing institutions and social arrangements will emerge along with visions of change. Because community cultural-development work is often financed or sponsored through existing (and imperfect) institutions, practitioners

frequently face conflicts between the interests of their funders or sponsors and those of the participants. For example, participants in a municipally sponsored project may wish to protest a policy of the municipality which adversely affects their community.

Such dilemmas have been described as conflicts between the "legal contract" and the "moral contract" of the cultural organizer. Adherence to a legal contract is honorable and vital to preserving community access to resources in good faith with funders and sponsors; but when forced to choose, practitioners must align themselves first with their moral contract with participants or risk that their work will be perceived as a form of manipulation or imposition, leading to deep demoralization for participants.

To avoid such situations, it is imperative that projects be protected with clear, written agreements specifying the responsibilities of all parties and ensuring practitioners and participants the right to determine project direction.

MATERIAL SUPPORT

Actual existing support for community cultural-development in the United States is a patchwork: bits of local, state or federal government funding, bits of contributed income from individuals, bits of foundation funding, strung together with attempts at entrepreneurialism, some successful, some not. This is far from ideal.

Community cultural-development is a social good, analogous to the provision of emergency health care or the establishment of public parks and universal education. It relies on individual creative workers who cannot be replaced by machines and who cannot adopt economies of scale that might reduce the need for their work. It cannot reliably be arranged so as to generate mass-marketable products nor to earn substantial revenues through such mainstream arts approaches as subscription ticket sales. Indeed, rather than being subject to commercial criteria, community cultural-development work should be seen as an element of protected public space within the culture, guarded from the depredations of commercial exploitation.

As a social good—part of the cultural commonwealth, just as protected lands are part of the environmental commonwealth—community cultural-development cannot be sustained by market-oriented means. Beyond the in-kind contributions of participants, its main sources of support must always be public funds, for its role in advancing the aim of animated, democratic community life, and private philanthropy, for its role in advancing cultural vitality and social justice.

INDICATORS OF SUCCESS

Community cultural-development projects are perceived to be entirely successful if:

– Practitioners and participants develop a mutually meaningful, reciprocal and collaborative relationship, useful and instructive to all;

– Participants enter fully into roles as co-directors of the project, making substantial and uncoerced contributions to shaping all aspects of the work and setting their own aims for the project;

– Participants experience a deepening and broadening of their cultural knowledge, including self-identity and a greater mastery of the arts media deployed in the project, with openings to further learning and practice as desired;

– Participants feel satisfied with what they have been able to express and communicate through the project;

– Participants' self-directed aims for the project have in their own estimation been advanced and any aims for external impact (e.g., sharing or distribution of products) have been achieved; and

– Participants demonstrate heightened confidence and a more favorable disposition toward taking part in community cultural life and/or social action in future.

While not every project will meet all these benchmarks, they should be consciously considered at the outset so they can help to shape the project as it unfolds and so evaluation plans can be designed with them in mind.

TRAINING

Advancing knowledge of community cultural-development values and approaches is a permanent, ongoing commitment. All participants—not just professional practitioners—continuously improve their ability to explore and apply the meanings imbedded in cultural traditions and arts practices.

Training for professionals must be grounded in direct experience, for it is not the transfer of a particular set of techniques which is required so much as the development of an outlook infused with culturally democratic values. Ideally, training should employ the methods it is designed to teach; accordingly, the training of practitioners in this field must incorporate the methods of community cultural-development. Apprenticeship and internship are prized as means to achieve this.

In order to facilitate ongoing advancement of skills and knowledge throughout the field, there must also be regular opportunities to share and compare experiences, thus challenging fixed ideas and encouraging new approaches.

To the extent that many practitioners continue to receive training in their art forms from mainstream schools of visual arts, drama, dance, broadcast media and arts administration, it is essential that the curricula of these institutions include history, theory and practical applications of community cultural-development, legitimating the work of community artists as part of the arts.

PROFESSIONALIZATION

Although full-time community cultural-development practitioners constitute a unique category of professional practice, this fact has not been recognized in any official way in the United States.

Left: Armando Molina of Cornerstone Theater Company portrays the Alien in "Token Alien," performed on a bus at Los Angeles' Museum of Contemporary Art. Photo © Lyle Ashton Harris 1997. Above, right: A community participant on the bus. Photo © Paula Goldman 1997. Below, right: The bus as theater. Photo © MOCA 1997

Here, they are most often seen as part of the professional category "artist," which is remarkably unburdened by professional ethics or expectations. No credentials, licenses or permits are required to practice as an artist; and no professional association or external authority has been set up to articulate standards. Add to this the pervasive skepticism in the field about institutions and it seems unlikely that professionalization of community artists per se will become a focus for some time to come.

The boundaries between commercial and not-for-profit cultural enterprise are becoming much more permeable. Younger artists, those who never experienced a time when public funding could be relied upon to provide essential support, have been more willing than their elders to experiment with market-oriented approaches or to try to "infiltrate" commercial cultural industries or academia. Indeed, because community cultural-development has been so little recognized as a profession in the United States, many community artists of all ages have found themselves working the borderlands between the better-funded art world and their own community-based practice. There, issues of professionalization can be vexed. What happens when a community artist makes a splash in the establishment art world, when a collectively produced play wins an Obie or when a recording born of a community project becomes a hit?

Unequal status has sometimes been perceived as an untenable threat, unfairly elevating one member above the rest; such success is problematized, sometimes leading to expulsion from the group. But if the field grows and continues to attract accomplished artists, it will almost certainly be necessary to work out a more complex relationship to the idea of mainstream recognition.

Outside the United States, there are associations of *animateurs* and "community workers," and there has been extensive discussion over the years of professional ethics, methodologies, training and even unionization. Many community cultural-development practitioners in other parts of the world are paid employees of development authorities, cultural authorities or other public agencies and thus are accountable to the same standards applied to other public employees. The requirements and benefits attaching to such public-sector jobs often influence the definition and working conditions of their counterparts in the private sector, concretizing the recognition of community arts as a profession. This in turn has set in motion debates about whether what is essentially an activating and liberating enterprise can be institutionalized without a loss of integrity and connection to community.

From such debates in other nations, it is evident that if a critical mass of attention and resources go into community cultural-development in the United States, making professionalization a real possibility, a primary commitment must be to avoid creating a special class of community cultural-development workers at some remove from the community members with whom they work. Under all circumstances, volunteers and those whose community cultural-development work is only part time or sporadic must continue to be mainstays of the field and no effort to separate them from professional practitioners would be consistent with the democratic values of the field.

A PARADOX INHERES IN THE CURRENT STATE OF THE COMMUNITY CULTURAL-DEVELOPMENT FIELD IN THE UNITED STATES.

Community cultural-development has never been recognized as a field per se by anyone other than its practitioners. Consequently, it lacks many of the infrastructural elements that typically characterize a field of not-for-profit endeavor: dedicated funding programs; a matrix of overarching organizations and publications to facilitate dialogue and cooperation within the field; and training programs and professional standards that reflect the best thinking of practitioners. The significant achievements of the community cultural-development field must thus be viewed as uphill victories. The greatest success is that so many convincing demonstrations of art's mobilizing power have been created with so little material encouragement.

These deficiencies stem not only from a lack of recognition and support—a withholding of these essential constituents of a field—but from a legacy of outright opposition from right-wing politicians and vested interests in the establishment arts. Freshest in popular memory is the opposition that arose around congressional appropriations for the National Endowment for the Arts (NEA) in the last decade. Federal budget-cutting was used as an excuse to eliminate controversial projects; community cultural-development work, which had relied far more on public funding than did prestige arts organizations, but had far fewer advocates with status and access to members of Congress, was hit hard in these cuts. The same vocal, well-financed minority continues to oppose any use of public funds to support arts work; should its views prevail, the result would be a kind of social Darwinism in the arts, with market success becoming the sole trait selected for survival of artists and groups. But another sort of opposition has been stymieing the field for far longer.

Let us cite another example we witnessed first hand. In October 1080, we covered a meeting of the policy and planning committee of the National Council on the Arts (the NEA's presidentially appointed advisory council) which was convened to discuss a study it had commissioned on cultural development in local communities across the country. The study recommended that the NEA support a policy of cultural democracy vis-à-vis local communities, making grants and providing technical assistance to local arts councils. It's hard to know which committee members' responses to quote, because so many were remarkable, but two should suffice to provide a flavor:

> I resent "cultural democracy" as a term, because it seems to use the "democracy," which we all swear by to our flag and to our faith; it subverts the term "democracy" into an autocracy of the uninformed—cultural democracy meaning that we have to be dictated to by those for whom we toil....

> [People] understand education, they understand amateurism, they understand community events—but they don't for a moment confuse what they're participating in with art itself.... Are we really in the business of supporting amateurism?... Where does it all end? The neighborhoods? With the streets?... The result can only be dilution, confusion and chaos.[35]

The underlying values of community cultural-development have long been perceived as a threat to certain interests. As the above quotations illustrate, some established professional arts advocates are appalled by the democratic idea that culture and creativity belong to everyone. On the most practical level, they fear that funds heretofore reserved for their own constituencies will be "diluted"—that is, shared with community cultural-development practitioners. In the political arena, the liberatory nature of community cultural-development is perceived as threatening the established order. And in the sociocultural arena, such positions as asserting cultural diversity as an asset and opposing a hierarchy of cultures can be an affront to those holding fast to the notion of an elite heritage-culture that ought to take precedence over all others.

< Community members working with Philadelphia's Village of Arts and Humanities transformed a desolate two-acre site (above, in 1999) into a tree farm (below). Photos © Village of Arts and Humanities 1999, 2000

35 The first speaker is Theodore Bikel, actor and president of Actors' Equity at the time; the second, Martin Friedman, was then head of Minneapolis' Walker Art Center. Quoted in *NAPNOC notes*, No. 6, Nov. 1980.

While usually rejecting the strongly democratic values of community cultural-development as insufferably impertinent, establishment arts funders have sometimes been susceptible to appeals to "cultural equity"—providing a fairer share of resources for institutions focusing on non-European cultures. Here and there, one can find African-American repertory theaters, Asian art museums, Latino media projects that have been able to win larger shares of arts funding, thus gaining standing and visibility within their art forms and mainstream art worlds. This is undeniably a positive development, as progress toward true equity is so long overdue and far too modest in relation to need and justice; but it should not be mistaken for a victory for the values of community cultural-development.

Cultural equity does not automatically equal community animation. While it may be moving and reinforcing to witness presentations of diverse works of art, it is not intrinsically mobilizing. A museum of African diaspora art may be as far removed from the cultural lives of ordinary people in surrounding communities as any elite European institution; an Asian-American repertory theater may have no more connection to empowering local community members than its non-Asian counterpart. The choice to advance community cultural-development—or to be concerned with different goals—exists regardless of ethnicity.

As noted earlier, community cultural-development projects have often been targets in the "culture wars" between fundamentalism and liberal humanism. For example, in 1997, right-wing Christian fundamentalist groups successfully pressured the city of San Antonio to eliminate what had been substantial, reliable funding for the Esperanza Peace and Justice Center, a three-time PACT grantee. The primary focus of this debate was Esperanza's sponsorship of San Antonio's annual gay and lesbian film festival. Esperanza's 1998 PACT application quotes the city's Mayor Howard Peak as follows: "That group flaunts what it does—it is an in-your-face organization. They are doing this to themselves." The politics of the situation are clotted with complexity: opposition to Esperanza was joined by representatives of several gay men's organizations who condemned the group's radical politics; the final decision to defund Esperanza was made by a Latino-majority city council; six months later, the city's Department of Arts and Cultural Affairs (DACA) recommended that Esperanza receive new funding; and six months after that, DACA rescinded its recommendation because Esperanza would not withdraw its lawsuit against the city of San Antonio, still pending as we write in the fall of 2000.

Two decades of holding artists and arts groups hostage to this culture war go a long way to explain why a movement that was so robust and promising in the '70s has not since been able to grow and develop to the status of a recognized field. Indeed, looking back at the literature of the movement at the time the first significant blows fell two decades ago—the election of Ronald Reagan, the elimination of CETA, drastic funding cuts in other agencies, and the demonization of art with a social purpose—one realizes that the majority of organizations that seemed to hold so much promise at that time have succumbed.

This encapsulates a generational story. The countercultural energy that infused the community cultural-development movement of the '60s and '70s was nourished by steadily rising hopes and expectations. In the very real achievements of the civil rights and anti-war struggles of that period, activists acquired a heady sense of their own agency. Within social-change movements, the line between

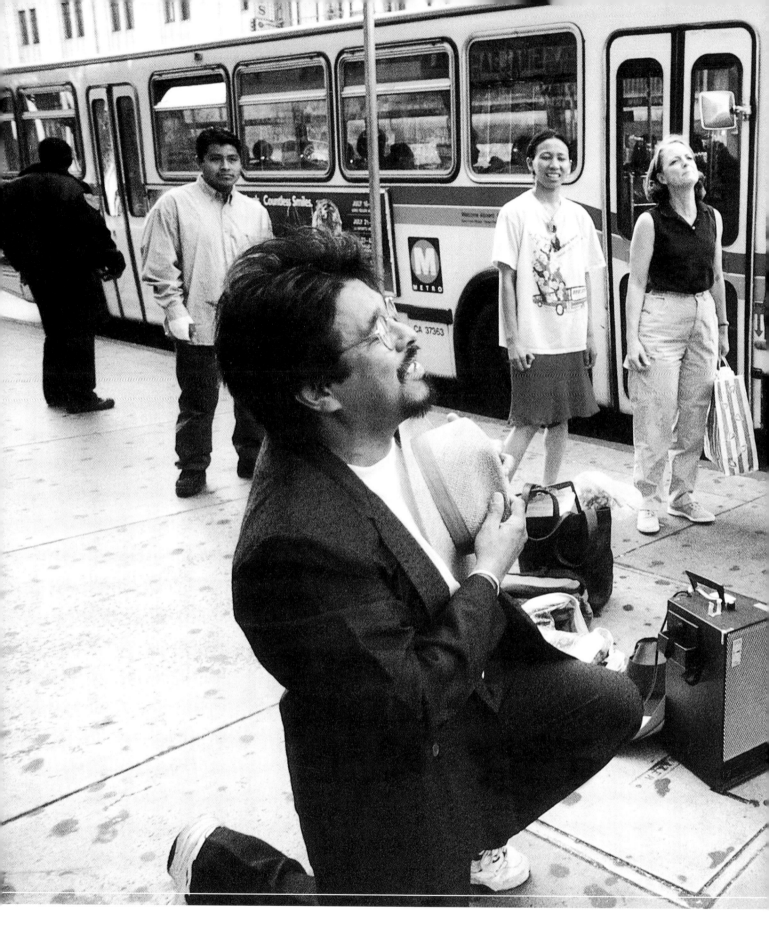

Teatro on the street draws attention to transport issues in a joint project of the Los Angeles Bus Riders Union, the Labor/Community Strategy Center and Cornerstone Theater. A rail contractor tries to derail Delores' >

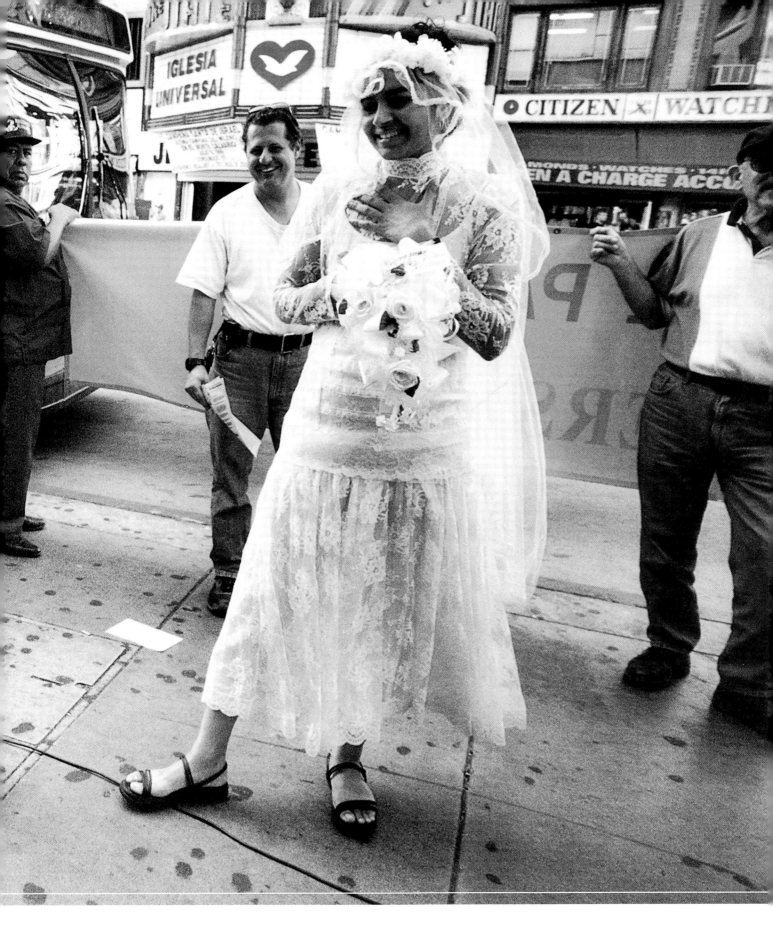

wedding when her fiancé is delayed by unreliable buses. Photo © Jorga Mujica/La Opinion 1999

healthy optimism and exalted delusion sometimes blurred, as when activists were lulled by their isolation from "mainstream" society into fantastic exaggerations of their own numbers and strength. The feeling that social arrangements were ripe for remaking was pervasive, but it seemed inconceivable that they would be remade to the specifications of the right. It is difficult now to grasp what a shock the election of Ronald Reagan was to this system of belief. The resulting demoralization was profound and persistent. Indeed, the optimistic view is that the recovery of hope is just beginning.

Many of the organizations supported by PACT come under the heading of "survivors" of this era. By and large, they have been able to endure because their leaders have possessed the dedication, resourcefulness and flexibility to constantly redefine their organizations so that they could be legitimated as adjuncts to other better-established fields. The most successful organizations have been able to simultaneously compete for funds from education agencies, argue effectively to arts agencies for their artistic excellence, persuade social-service agencies of their skill in advancing social-welfare aims and so on.

> I made the decision to speak in many tongues to get the support we needed. I spoke the professional artistic language and made sure all the artists are on that level. I got a degree in social work to get into the elder facilities, because they'd say "we don't want artists"; and recently I learned the educational and school-reform language.

This has set the threshold for success very high. It is not enough that the work itself be of real quality, demonstrably living up to its claims. To keep afloat, groups have had to be able to bring remarkable effort, diligence, skill and adaptability to the task of finding support, very often requiring them to distort their aims or methods to do so. Understandably, many complain that it takes a prodigious investment merely to stay in place, and that at times it feels as if the tail is wagging the dog.

The meta-theme of our interviews with community cultural-development practitioners is this: We survived. In recent years, as recognition of the effectiveness of community cultural-development practice has grown, as it has increasingly been seen as addressing the need for greater social inclusion, dialogue and participation in shaping community life, some community cultural-development groups have been quite successful in attracting support and expanding programs. The lessening of survival fears has allowed them to engage with the question of what the field as a whole needs in order to flourish. As the old arts orthodoxies crumble and the right's grip on cultural politics begins to loosen, we once again begin to hear harbingers of resurgent activism and interest in this field.

There are fewer organizations dedicated to community cultural-development today than there were 25 years ago, but a significant cohort of surviving groups has now been working continuously for 20 or 30 years. They are reporting a tremendous upsurge in interest in their work, especially from young people attracted to work that is meaningful, despite its few material compensations.

> No one understands how many people are wanting to do this. I meet so many young artists who want to do meaningful work—to work on issues and do something meaningful in communities. There are more every day. I just wish I had work for them.

Sometimes cultural phenomena can only be explained by resort to the zeitgeist. Surely it is the spirit of the times—the current conditions described at the beginning of this volume, urgently demanding democratic response—that accounts for the speed with which community cultural-development approaches are spreading in the United States, within the arts community and beyond.

Consider the projects funded under the Rockefeller Foundation's own MAP Fund, earmarked to support new creation in the performing arts, without any requirement that applicants adopt community cultural-development values or methods. In 1997, for instance, 25 percent of the 36 funded projects incorporated significant elements of community cultural-development. For example:

– The Bloomsburg Theatre Ensemble's *Coal Project*, a musical-theater production that tells the region's stories in its own voices, based on oral-history material collected from coal miners past and present.

– Contemporary Dance Theater's grant for *At the Crossroads/Nagasaki in Black* led by playwright Keith Antar Mason, based on collaborations with Cleveland organizations of African-American men and incorporating young African-Americans from the local community.

– Dance/Theatre/Etcetera's grant for *Safe Harbor* by choreographer Martha Bowers, which used the Red Hook neighborhood of Brooklyn to explore themes of community, safety and immigration, with broad participation from neighborhood residents.

– A grant to the Los Angeles Poverty Department, a performing company that works with homeless people, for *Taking Back My Neighborhood*, a site-specific work performed at various locations in the Skid Row area of Los Angeles.

Not all of the artists involved in these MAP grants may think of themselves as community artists and not all of their projects would be identified by their originators as community cultural-development (as opposed to an experimental theater project, for instance, or a site-specific performance). Certainly, not all are guided by the field's implicit consensus on values and approaches as described in earlier sections. But with or without conscious intent, these artists are being pulled toward community cultural-development and that pull clearly results from the influence of community artists who do consciously identify with this field.

Looking beyond the United States, the landscape is even richer, because community cultural-development movements abroad have mostly been able to develop their own approaches, methods and standards while public and private funding sources have continued to support them, though funding has become more project-oriented and competitive with the trend to "privatization" described in Chapter Four, Historical and Theoretical Underpinnings.

This has brought the domestic field to a sort of crossroads. There are both narrow and wide definitions of the scope of need. Narrowly defined, community cultural-development is a phenomenon of great, demonstrated promise, perpetually under siege. A strong argument can be made that surviving

Young people work with Elders Share the Arts artist Jeff Bliss, then gather stories for use in the "Park Respect" >

practitioners should be supported so that their influence can continue to spread. But the wide view of the field's scope is much more exciting: the aims of the field are nothing less than the enlivening of democracy in the face of globalization, the realization of pluralism, participation and equity. In relation to these aims, what's currently supported—the surviving remnant—is minuscule. Compounding the obstacles described at the head of this chapter, funding policies play a significant part in keeping it that way.

In a climate of funding scarcity, competition discourages the cooperation, networking and commitment to common cause necessary to solidify a field. The exigencies of fund-raising encourage organizations to present themselves as unique, to the point that a few treat methodology almost as a form of proprietary knowledge. Success in this climate tends to swell existing organizations rather than encourage the proliferation of new ones, even when the latter strategy would be more in keeping with both the public interest and the values of the field.

Right now, commercial cultural industries and academia seem to many young artists to offer more attractive options than the realm of nonprofit arts organizations, which seem to require attachment to a life of struggle and material self-deprivation. Given this tendency, it is remarkable that community artists report inquiries from large numbers of young people attracted to community cultural-development. But it is likely that these young people will be lost to the field, because there are too few existing groups and too few resources in the current configuration to employ them. Unlike the situation in the '70s, support is not available to young people to start their own organizations—despite the fact that doing so would advance even some establishment-arts aims.

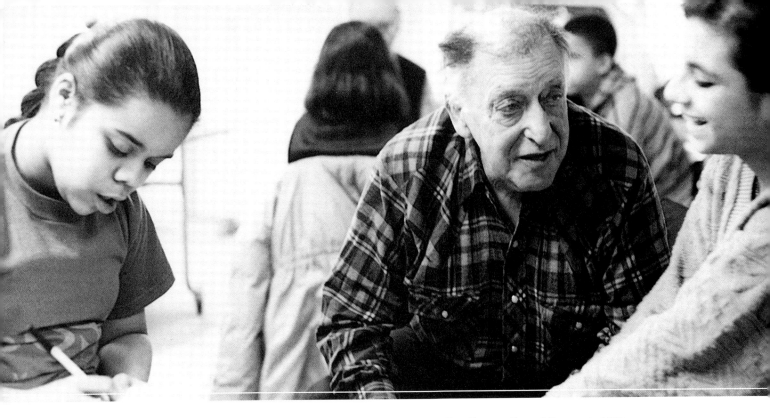

project, focusing on reclaiming their local neighborhood park in New York City. Photo © Howard Pomerantz 1992

For instance, one of the great obstacles to increased arts funding in the United States has been the participation barrier. There is simply a limit to many public and private funders' willingness to subsidize what benefits a privileged audience. The audience for red-carpet arts institutions has remained largely white, middle-aged and older, educated and prosperous, despite elite arts institutions' substantial, continuing investments in "audience development" strategies, looking—as their European counterparts did in the '60s and '70s—for a magic formula to sell their offerings to ordinary people. Will busing them to performances work? Will they respond to discount passes to museums? Will high-profile advertising campaigns do the trick?

Meanwhile, community cultural-development practitioners have adopted the opposite strategy. Instead of trying to persuade the audience to change, they recognize that the form, content and aims of the artwork must change so that they come to matter to the audience.

As a result, while the bulk of arts funding goes to establishment institutions, it is community cultural-development work that is most often trotted out at legislative hearings to justify cultural subsidy. To people in non-arts fields, it is community cultural-development that makes the most convincing case for the power of art.

The key question remains whether this situation will be recognized, leading to support for the field's developmental needs, as outlined in the next chapter.

was conducted to inform the Rockefeller Foundation's support for the community cultural-development field, so it contained detailed recommendations for modification and augmentation of the Foundation's own programs. The study has already resulted in some encouraging initiatives, such as the introduction of multiyear PACT funding, funding for training and professional development initiatives and plans to address the implications of this work in helping communities around the world respond to the forces of globalization by convening practitioners and publishing their thoughts.

7

DEVELOPMENTAL PRIORITIES FOR THE FIELD

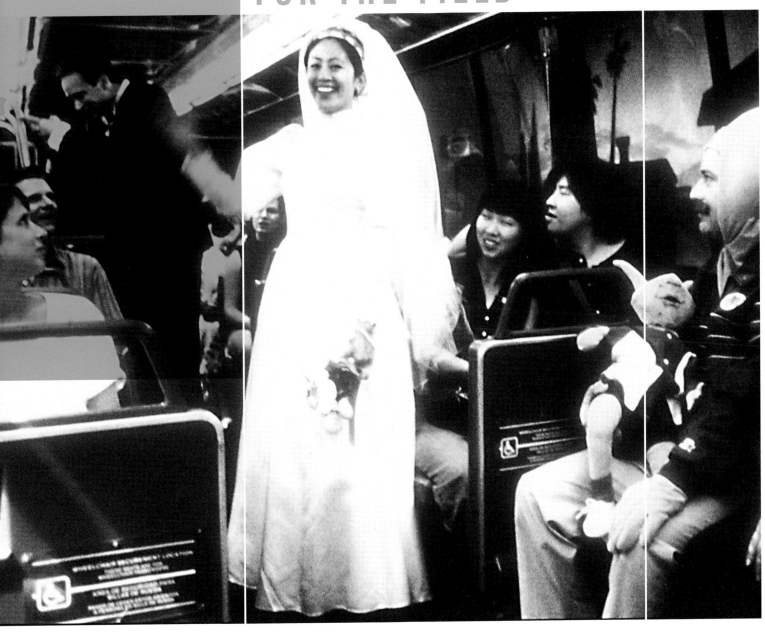

But no single funder or institution can address more than a small fraction of the need. Developmental steps need to be taken by practitioners and critical resources must be made available by resource-providers. Recognizing that, this chapter has a dual purpose: to explore the field's primary needs for internal infrastructure and exchange, public awareness and material support; and in each case, to suggest several things that can be done to help fill the need, as well as questions that could be productively discussed.

INTERNAL INFRASTRUCTURE AND EXCHANGE > In the past, national organizations have been created with the aim of convening community cultural-development practitioners to develop common language and theory, share experiences and pursue collective aims.

> The chance to communicate about obstacles and solutions is really important, the chance for cross-learning. In the early days of [Alternate] ROOTS, people were working in isolation. That's what it's like nationally now. There needs to be training, since community cultural-development implies certain methodologies, approaches and values. It seems to be a trend or a hot-button issue among funders: people are jumping on the bandwagon without having any notion of what the issues are. I don't want to restrict support to those who've been doing it for the last 20 years, but I do want there to be a sense of standards.

The organization most frequently mentioned in our interviews was the Alliance for Cultural Democracy (ACD), formerly the Neighborhood Arts Programs National Organizing Committee, which we directed from 1979-83. ACD always struggled for survival and is no longer active as a national organization. Most speakers who cited the organization were referring to their own involvement in the '80s.

> I got so much out of being on the Board of the Alliance for Cultural Democracy. I'd get so rejuvenated from the meetings—the networking, the ideas, funding suggestions. People would come from everywhere.

Other interviewees mentioned Alternate ROOTS, which has continued to provide similar common ground for practitioners in the performing arts, particularly in the South. ROOTS' "Community Arts Revival," held in Durham, North Carolina, in January 1994, brought together leading practitioners and theorists from across the country, demonstrating the possibility and value of such gatherings. A meeting of PACT grantees in October 1998 was mentioned by several participants. The National Performance Network's community arts caucus, a more narrowly focused group comprising those NPN members who see themselves as community artists, was mentioned by a couple of interviewees.

The field needs to convene face-to-face meetings of practitioners and theorists. There are many ways to communicate—and more are being introduced all the time—but so far, nothing can replace the synergy of face-to-face meetings, with time for formal exchange and debate as well as making the powerful informal connections we now call "networking." It is not clear if any existing entity can serve a convening and unifying function for the field as a whole. Rather, two alternatives were suggested by our interviewees' comments.

< Page Leong of Cornerstone Theater Company portrays the bride in "Token Alien," part of the "bUS pLAY" series at the Museum of Contemporary Art in Los Angeles. Photo © MOCA 1997

The first is to continue to use all available existing networks as host organisms, pulling together within larger frameworks caucuses and events that speak directly to community cultural-development practitioners. This seems wise, but it is difficult to see how community cultural-development practitioners would be able to secure the space and time necessary for the type of sustained dialogue most needed now in the context of other organizations' conferences. Practically, the tactic of piggybacking onto other organizations would probably serve more effectively to broaden public awareness than to advance the internal development of the field.

"We Wear The Mask" performed by the Youth Theater project of Philadelphia's Village of Arts and Humanities. Photo © Village of Arts and Humanities 2000

The second is to begin with a coalition of existing organizations and networks within the arts fields and beyond, so that the same initiatives serve to both solidify and broaden the field.

> *I see a lot of start-ups, but they tend to be social service, organizing, labor—other areas of social activism, but using the arts. There were many such people at the National Organizers' Alliance [meeting] who wouldn't consider themselves arts organizations or artists, but they're doing this work. We need to broaden our notions of where this work is happening. We need stronger connections with people doing community animation in the broadest sense. It's a problem that the community arts idea has resided in the arts world rather than the greater social context. And it's still on the periphery of arts organizations, which are in turn peripheral to the wider society. In addition to continuing support to arts groups, encourage [community development organizations] to do this work. Over time, they'll incorporate this into how they work. Otherwise this will just remain a ghetto within a ghetto. We need to widen the notion and extent of this work, until it's included in the day-to-day, month-to-month, annual planning of non-arts organizations. Now, they usually just respond to invitations from the arts community; otherwise it doesn't come up.*

The field needs to sustain the widest possible dialogue through print and online communications. Meetings are essential, but if real dialogue is a goal, they entail limitations of scale. Regardless of how successful a meeting is, no face-to-face meeting can ever serve an entire field. Journals, Web sites and other methods of sharing and discussing ideas and experiences are needed. Thus far, there has not been the wherewithal to support an organization capable of sustaining these elements of infrastructure for the field.

For years, the journal *High Performance* served as the main such U.S. publication in the field. Interestingly, it began in 1978 with the intention of covering performance art; then, as its founders' interests and artists' focus began to change, reinvented itself in the late '80s as an organ for community artists and their work. At what many in the field would call the height of its influence in 1997, the journal folded due to lack of funding. Currently, *High Performance*'s parent organization, Art in the Public Interest, has teamed with Virginia Tech's Department of Theatre Arts' Consortium for the Study of Theatre and Community to produce an online community arts newsletter (API News, available at <www.apionline.org>). The online publication features brief snippets of news and links to useful Web sites, but does not provide the sort of sustained discussion or analysis more typical of print publications. It is not yet clear whether this collaboration might support this kind of field-building dialogue.

Whether it might be filled through the revival of *High Performance* (or the creation of something like it) or through an expansion and focused use of multiple organizations' publications, to write about the work, to discuss its underlying ideas, and to exchange experiences are key to the solidification of the field.

Finally, the field needs to devise high-quality training opportunities consonant with its values and approaches. Any field needs ways of extending itself by passing along knowledge and skills. As

discussed in Chapter Five, Theory From Practice: Elements of a Theory of Community Cultural-Development, it is challenging to design training modes that embody the democratic, participatory values of community cultural-development practice. One point of virtual unanimity is that an academic program removed from "the trenches" of day-to-day community work cannot succeed.

> *People should get together for training in critical analysis of how change happens—power analysis, cross-cultural communications, conflict resolution, problem-solving, group process.... We need more discussion of experience: what's changing? What adjustments are needed?... People are coming out of university settings, getting a conservatory approach to the craft, just focusing on your chops. [To put them into community-development work] is really dangerous for the communities being led by these artists, dangerous for organizations working with them.*

As noted earlier, ongoing, practice-based training is widely perceived as both the best approach and a crying need. Many experienced practitioners active today entered this work having been trained as artists and simultaneously involved in social-justice movements. Clearly, they prize the type of on-the-job training through which they formulated their own approaches; and when their organizations are able to add new community artists to their staffs, they try to replicate it. But no one has been able to obtain the resources that might enable them to formalize and extend this type of training beyond the few incipient community artists who receive training as newcomers to their own organizations.

> *Training is non-existent... We're still trying to figure this out. But at the formal level, it's still really early. For example, since Paulo Freire made such a big impact back in the '60s, we're just now seeing the first critical pedagogy PhD program in 1998. It's clearly still bubbling.*

Similarly, continuing education for practitioners—honing skills, encountering new situations through exchanges with other organizations, finding the opportunity to pull back and engage in self-examination and self-improvement—these typical self-development activities of a field are still merely dreams to most community cultural-development practitioners.

> *A real lack for me are some really good vehicles to record this work, much less to talk about it, theorize.... There are a lot, a lot, a lot of artists operating as arts entities, trying to make linkages with community people. I'm interested in conferences, publications, exchanges of writing that create this all as a thing...to raise the level of theory, based on practice, about working with the level of difference that we're talking about—every race, class, geographic distribution, gender, sexuality.*

SOME SUGGESTED RESPONSES TO THE NEED FOR INTERNAL INFRASTRUCTURE AND EXCHANGE

Grantmakers' support for meetings is vital to building infrastructure for the community cultural-development field. There are many ways to do this. Small stipends can be made available to community artists to attend, caucus and offer presentations at larger meetings relevant to their work.

Regional funders can work with coalitions of community cultural-development practitioners to pull together gatherings in their own regions. National funders can earmark a pool of discretionary funds for use in underwriting the most promising proposals they receive.

Grantmakers' support is needed for online and print publications to sustain networking, information exchange and dialogue. We recommend that any effort to provide this support begin with organizations that have proven most successful at such publishing in the past.

Recognizing that community cultural-development practitioners are in many cases part of an advance guard against the destructive impacts of globalization, **financial support for international and transnational opportunities for practitioners to exchange and learn is crucial.** For example, grant support could enable African, Asian and American groups focused on development-related issues in rural areas to compare methods and experiences and produce a publication or Web site useful to their counterparts around the world. Or a joint grant could go to two community cultural-development groups—say, a North American and a Central American group working in a "cultural corridor" relationship, Néstor Garcia Canclini's rubric to describe two cities or regions linked by a well-established pattern of immigration—for a project focusing on themes of shared heritage and migration.

In this connection, opportunities should be researched for funding partnerships between U.S.-based and international foundations. Some possible partners are the Gulbenkian Foundation, which has provided extensive funding for community cultural-development projects, primarily in Britain and Portugal; the European Cultural Foundation, which is open to multinational Europe-focused projects; and the many partners in the international development-focused project, The Communications Initiative at <www.comminit.com>.

Grantmakers should support training and professional development initiatives that emerge from the field. Three models seem particularly promising:

1) **Providing apprenticeship and internship fellowships to established groups of proven accomplishment for on-the-job training.** We recommend providing one-year fellowships to support individuals chosen by the applicant organizations; in most situations, $35,000 would support an entry-level annual stipend and attendant costs. Even 10 fellowships per year would dramatically expand the field's current training activity, for a total annual allocation of $350,000 plus the costs of administration.

2) **Making highly selective multiyear grants to underwrite established groups in incubating a new initiative that will spin off into an independent start-up.** The first year of such a grant could finance an in-house development process, putting organizational plans and infrastructure in place while action-research projects are carried out, piloting approaches and building relationships; the second year could underwrite establishment of the new project as an independent entity as its work continues; the third and final year could invest in stabilizing the new group as its working relationships and approaches grow stronger.

3) **Supporting professional development projects in which exemplary groups work together for mutual self-development.** Examples might be a weeklong training institute cooperatively mounted by oral history-based community cultural-development projects, to work on practical and ethical issues relating to oral history and new media; or by producers of community cultural-development programs for youth, involving both young people and adult practitioners; or an exchange program between two community video projects that places a practitioner with needed (but different) advanced skills in each organization for a period of months, resulting in reciprocal training.

Community cultural-development practitioners should take advantage of networking and convening opportunities to explore key questions for the field, including these suggestions:

– *Professional ethics for community cultural-development*: Should the field develop codes of conduct and if so, what are the essential ethical commitments that such codes should reflect?

– *Aims for the field*: Are there common aims that transcend internal distinctions in the field? Can practitioners articulate a common platform? If so, what would it comprise?

– *Criticism for community-based work*: What values, processes and aims should shape a constructive, substantive criticism that really serves the field? Any inquiry should begin with Liz Lerman's excellent "critical-response process," with its stress on respect for the artist's intentions, which has gained wide use among performing artists in the field.[36] Beyond process, however, lie vital questions of shared and individual standards, aesthetic judgment in the presence of multiple cultures and intentions and, always, the challenge of devising appropriate criteria for community cultural development processes as well as for any products they generate.

– *The content of community arts training*: What do practitioners need to know about action-research, group dynamics, artistic skills, community organizing and other areas of knowledge? What are the consequences of imbalances in knowledge? Where is on-the-job training most effective and where does it fall short? How can it be appropriately supplemented with other forms of learning?

PUBLIC AWARENESS > Given the basic, formative help required to solidify the community cultural-development field, its most fundamental need is legitimation: its recognition as a field, with all this entails. Merely to take part in the articulation of that reality—that community cultural-development has its own values, standards, aims and methods, which can and should be analyzed, communicated and taught—will help to advance the field. One of our interviewees made this point in relation to the Rockefeller Foundation:

> *To become a field, this would need a lot of developmental attention in a lot of different ways.... Rockefeller has cachet, so...their recognition through convening people, naming this work, giving grants, to produce learning and circulate it, that would be of enormous help... Anything they can do to keep the doors open, to keep the conversations open, to keep supporting those who are doing this very difficult border-crossing work is very important.*

36 Liz Lerman, "Toward a Process for Critical Response," *High Performance* 64 (1993), pp. 46-49.

Too long limited in aspiration to mere survival, the field needs to focus on expanding to every community. Such legitimation is in many ways a prerequisite of wider public awareness, leading to the proliferation of community cultural-development activities.

That every community should have access to empowering creative experiences, that this work should not be reserved for a lucky few—this is an article of faith in community cultural-development circles. Indeed, one particularly enlightening way to look at the goals of community cultural-development is to see them as making a human right of what was once considered a privilege:

> [I]ts aim is to arrange things in such a way that culture becomes today for everybody what
> culture was for a small number of privileged people at every stage of history where it suc-
> ceeded in reinventing for the benefit of the living the legacy inherited from the dead....[37]

Realization of this aim would require providing the means of community cultural-development in every community—facilities, skilled practitioners, materials and equipment and so on—making such programs as commonplace as public libraries. The gap between the present reality and this vision of the future is a yawning Grand Canyon. To bridge it will require a huge effort to stimulate public awareness of the right to culture, which is now so obscured by denial and neglect that it is essentially invisible.

Such an effort would require skilled communications and coordination. Like the process of internal exchange described in the previous section, these could be undertaken by an overarching organization created to solidify the field or by multiple organizations working in concert to guide a joint campaign. Coordinating the collaboration of existing organizations seems more practical than trying to create a whole new group. But it is impossible to imagine even this being accomplished as a voluntary, decentralized add-on to the work of existing community cultural-development practitioners, whose hands are full with the tasks of surviving and making their own direct community work as effective as possible with too few resources.

The community cultural-development field must contribute to the creation of helpful public policies. In countries outside the United States, awareness of community cultural-development as a need and opportunity is advanced through the articulation of public cultural goals, embodied in cultural policy. Virtually every country has adopted formal cultural policies, laying out public aims for cultural development and creating mechanisms to channel support to artists and organizations whose work promises to advance those goals.

For a long time, official U.S. policy—unique among the nations of the earth—was to refrain from articulating policy. Instead, officials claimed that it was in the national interest that public policy should follow the lead of private subsidy, with no independent goals. In practice, this has made domestic cultural policy a catch-as-catch-can affair, allowing the bulk of federal subsidy to be channeled to wealthy institutions, those most capable of attracting large amounts of private funding.

37 From Francis Jeanson's "On the Notion of 'Non-public,'" quoted in *Cultural Democracy*, No. 19, Feb. 1982.

When the anti-arts funding debates gained momentum in the early '90s, this no-policy policy left the public sector in a weak, defensive position, unable to articulate convincing reasons why the government should care about cultural development. (Arguing that ordinary taxpayers' priorities ought to obediently follow those of wealthy arts patrons isn't exactly a crowd-pleasing platform.) The weakness of arts-funding defenders' arguments led to a de facto "squeaky wheel" policy: the institutions most able to mobilize major political donors in their defense have suffered far less from public cuts than those whose constituencies are distant from seats of power.

Until the beginning of the Reagan administration in 1981, public support was the mainstay of community cultural-development work in the United States, as it is in every other nation and as it must be if the goal of universal access to community cultural-development is ever to be realized.

> Both public and private support should be developed. What's needed is some sort of public cultural policy. Greater respect at the federal level could have impact on all the other funders, making this work more visible so the private sector could pay better attention.

Given that public subsidy is so necessary to a thriving community cultural-development practice, it is striking how utterly demoralized virtually all of our interviewees were when they spoke of public cultural policy.

> The [National Endowment for the Arts] should be doing all these things we're left to try to do ourselves—proselytizing, spreading information—to educate and inspire the country. To challenge arts professionals and organizations to proceed with local and regional efforts and reinforce all this with quality criticism. But I just don't see how this is going to change.

Our hunch is that a renewed focus on broad, democratic public cultural policy (as opposed to narrower current interest in arts-funding policy) will come when the field has been able to put key elements of infrastructure in place to sustain dialogue and concretize a sense of common purpose. Only then might there arise the political will to tackle the problematic absence of democratic policy in U.S. cultural affairs.

SOME SUGGESTED RESPONSES TO THE NEED TO EXPAND PUBLIC AWARENESS

Grantmakers' support is needed for focused efforts to legitimate the field, bringing it public recognition and influence. An example from the Rockefeller Foundation's past is instructive in this regard. In 1988, when the Foundation was focusing its considerable influence on intercultural relations and multicultural development, the Arts and Humanities Division cosponsored two major conferences with the Smithsonian Institution on "The Poetics and Politics of Representation," specifically highlighting museum practices in exhibiting non-European cultures. *Exhibiting Cultures*, the 1991 Smithsonian Institution Press volume that emerged from these gatherings, is still considered one of the most influential texts on the subject and is widely used in museum-education and curatorial-training curricula. It has helped immeasurably in increasing the cultural sensitivity of museum practice and has also legitimated important voices that would not otherwise have influenced that field.

A concrete play sculpture designed by Liz Leyh of Inter-Action, one of the first British community arts projects, and residents of Netherfield Public Housing Project in the 1970s. Photo © Alex Levac 1974

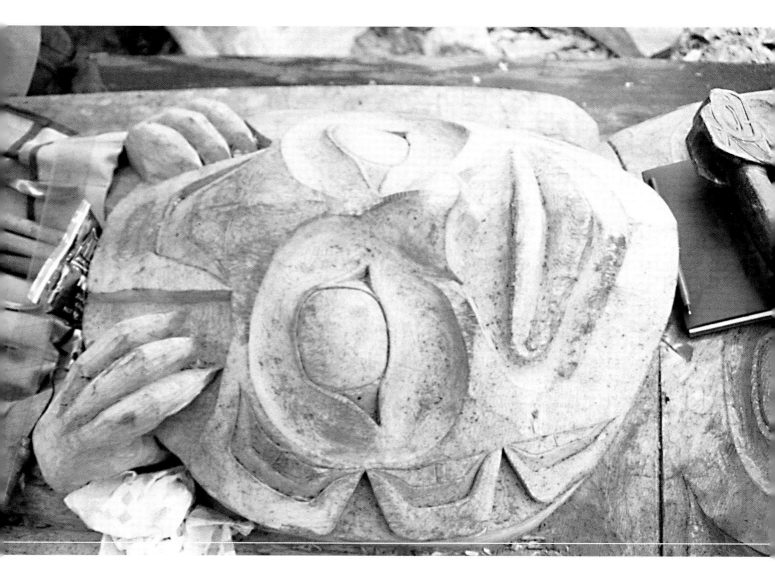

A detail of the Healing Heart Totem Pole in Craig, Alaska, commemorating a young man who died from a drug overdose. Photo © Merry Stensing 1995

Community members help carve the Healing Heart Totem Pole in Craig, Alaska, commemorating a >

young man who died from a drug overdose. Photos © Merry Stensing 1995

In similar fashion, funders (singly or jointly) could convene a series of meetings aimed at consolidat-ing lessons learned from the last three decades of community cultural-development practice and pro-ducing a similarly influential publication. Possible cosponsors include educational institutions, major foundations or regional arts agencies. Such an effort should start with a representative planning group to develop a framework, participant lists, cosponsors and publication partners.

There should be a general effort to acknowledge and include the history and accomplishments of the community cultural-development field in related educational settings. Too often, academic departments privilege a certain sector of the relevant professional fields, as if all visual arts students would become successful gallery artists, all theater students could find work in New York or regional repertory, all media-makers were headed for successful careers in feature films, all arts administrators would find cozy niches in major institutions organized on the corporate model. Omitting community cul-tural-development from the curriculum denies students potentially useful information about alternative modes of creativity and livelihood; it also helps to perpetuate the field's marginality, as lack of acknowl-edgement begets future neglect.

Grantmakers' support is needed for collaborative projects that introduce and demonstrate the strengths of community cultural-development practice to activists and organizations in other realms. For example, many funders support programs to strengthen non-arts nonprofit agencies by supporting such activities as participatory planning, organizational development assistance, and enter-ing into strategic alliances. These suggest a natural match with community cultural-development practi-tioners, who could animate such processes using arts and cultural media. Similarly, funding programs that address fundamentally cultural issues such as race relations could support community cultural-development practitioners collaborating with grantees to bring powerful new cultural tools to such efforts. Partnerships like these, involving community artists with activists and organizations in better-networked and more visible social-change sectors, would help a great deal to raise the profile of the community cultural-development field and enhance the effectiveness of social-issue organizing.

Such collaborations might well start with training and dialogue opportunities. For example, a funder could convene groups of grantees with a range of community cultural-development practitioners to get acquainted, discover potential applications of community cultural-development practice to the grantees' work and explore possible collaborations. Funders with divisions in the arts and in social-issue areas could support such activities jointly, drawing on the expertise and contacts of both arts and non-arts divisions.

Everyone concerned about cultural development in the United States—funders and practitioners alike—should focus freshly on the question of democratic public cultural policy. The emphasis here should be on fresh response. The current debate is hemmed in by defeatism, expectations low-ered to the point of invisibility, and tired special-interest pleading by the supporters of prestige institu-tions. Surely making common cause with broader publics is necessary to move the debate beyond its

current narrow status as a conversation internal to the art world. No real change in cultural policy or provision is possible if ideas such as, public-service employment in cultural development, supporting community artists for their roles in raising awareness of public issues and providing community cultural-facilities in every locality are never seriously put forward (or immediately dismissed from consideration as too ambitious for the realpolitik of the moment).

Community cultural-development practitioners should take advantage of networking and convening opportunities to explore key questions for the field, including these suggestions:

– *Raising visibility:* What initiatives would do most to raise and highlight community cultural development work? What constituencies need to know about the work, and what are the best ways to reach them?

– *Promoting collaborations:* What sectors of social activism and education seem most suited to collaborations with community artists? What training opportunities, demonstration projects or other initiatives seem most worthy of exploration to promote these collaborations?

– *Public policy proposals*: Considering the wide array of possible policy models put forward in this country and around the world, what values, initiatives and safeguards ought to characterize public policy for cultural development? What strategic alliances and intermediate steps hold most promise in terms of building a democratic cultural-policy apparatus?

MATERIAL SUPPORT > The most pressing need perceived by community cultural-development practitioners, a chronic problem which has become more serious over the past two decades, is finding the wherewithal to continue their work.

> *It's terrible, just terrible. Funding for community-based work and especially for long-haul community-based work—it's just not there. There was a burst of this work in the late '60s and '70s and the availability of funding creates enthusiasm.*

Many conscientious funders are concerned to reduce the "who you know" character of grantmaking, introducing innovations to prevent grants officers' personal proclivities from determining philanthropic choices. Nevertheless, familiarity often breeds reassurance. There is a revolving door between red-carpet arts institutions and arts funders, with individuals moving from jobs in producing or presenting organizations to jobs in the philanthropic sector (and back). This leads to ease of access and social compatibility.

In contrast, many community cultural-development practitioners have enduring commitments to a particular region or organization, sticking with a job or group for long years, ascribing to the manners and mores of their home communities rather than the customs of the cultural-philanthropic complex. Many community cultural-development groups diverge from standard corporate norms in terms of struc-ture and management style: they may be worker-managed, make decisions collectively, assemble

boards of community representatives (instead of emphasizing donors or social connections, as so many prestige arts groups do) or use idiosyncratic self-devised management systems rather than adopting the perceived "best practices" of the mainstream.

The perception is that funders' own cultural biases and blind spots have too often overshadowed the good results that should justify ongoing funding for community artists, releasing those with good track records from constant fears about survival. If enough of funders' perceived signifiers of stability or trustworthiness are missing from a group's self-presentation, such cultural differences can add up to fund-raising trouble.

General operating support should be promoted as a critical fieldwide need. Even more than other types of arts-related organizations, community cultural-development groups need reliable, ongoing support. As discussed earlier, knowing their survival is not in jeopardy frees them to collaborate with communities in an open-ended way, allowing each project's timeline and outcomes to emerge from the collaboration. Ongoing operating support also reduces community artists' vulnerability to censorship or political attack, breaking the potentially punitive cycle whereby a group is only as secure as its last project.

One has only to look at the most fertile periods of invention and accomplishment abroad to see how reliable operating support contributes to growing sophistication of theory and technique. In its heyday in the '70s and early '80s, the British community arts movement, with dependable public "revenue funding" (i.e., general operating support) was an incredible laboratory for experimentation in assisting self-directed community development through cultural work; today, much of the energy to innovate and much of the commitment to democratic principles seems dissipated.

The way funders have expressed their discomfort with community artists and thus hedged their bets has been to channel money largely through time-limited project grants, necessitating a perpetual cycle of packaging, fund-raising and repackaging that obscures the strong spine of the work, focusing attention on the superficial differences that make an attractive project package.

> One flaw in the funding system is the addiction to new projects—not supporting ongoing stuff.... My gut sense is that there's a crisis in confidence among funders about the management capacities of community-based organizations. They don't see the endowment, they don't see the cash reserves, they don't see the kind of stability they see in larger institutions they're funding. They feel more comfortable working with organizations that look like them[selves]. They need to see that these groups are really well-run and should get support. Community-based groups are interested in accountability, so their board composition is different, and they have a different relationship to fund-raising: it's just not the board's function. So we need to educate these people about what stability and good practice looks like in these smaller organizations.

Project grants are not only more labor-intensive, they lead almost irresistibly to practices that—ironically—further shake funders' confidence in the field. Project grant guidelines often encourage inflated

A scene from "A Beautiful Country," presented by Cornerstone Theater Company, in association with East West Players and the Mark Taper Forum's Asian Theatre Workshop at Chinatown's Castelar School.

Photo © Craig Schwartz 1997

claims, by requiring that proposed projects successfully resolve the problems or needs that brought them into being, usually within a specified time span (most often a year) and do so on the basis of measurable outcomes that can be predicted. One way to handle this disparity is to ensure that final reports on funded projects bear as little relationship to reality as did the proposals that got them funded. The alternative is to be honest, but when performance almost inevitably falls short of impossible aims, "poor planning" (rather than unrealistic guidelines) is often seen to be at fault.

Without general operating support, funding is always a patchwork of different modes and sources, often with different aims and evaluation criteria to satisfy. Fund-raising occupies a disproportionate amount of time and creative energy.

The field needs to make its unique economics widely known. Earned income is a mainstay of mainstream arts organizations in the United States: for example, Americans for the Arts' figures for overall nonprofit arts' income put earned income at 50 percent of the total, individual contributions at 39 percent, foundations at only 3.5 percent and government subsidy (federal, state and local aggregated) at just 5 percent. But community cultural-development is different. When public funding programs such as CETA (discussed in Chapter Four, Historical and Theoretical Underpinnings) were active, they filled much of the gap created by community artists' distance from sources of wealth. Similarly, at key points, private foundations with compatible social and aesthetic missions have provided much more than 3.5 percent of some community artists' support.

With very few exceptions, earned income has not been a significant contributor to sustenance for groups engaged in community cultural-development. This is intrinsic to the nature of the work. By definition, market-oriented arts work is other-directed, focused on producing those objects or services most attractive to buyers. It is antithetical to the process orientation and self-directed nature of community cultural-development that it should be required to produce marketable products. Occasionally, there is a fortuitous confluence of interests (as when the animating force behind a community's involvement in a project is the desire to tell its story to the larger world via a video, audio recording or publication for which there is ultimately a market, however modest). But, as noted earlier, the labor-intensive enterprise of assisting communities in making their own cultural meanings and taking cultural action comes under the category of social goods, such as public education or environmental preservation, that cannot be market-driven.

Although their level of investment has been modest in relation to needs, the decline of public funding has thrust private foundations into the limelight as primary sources of support in this depleted U.S. field. Even with its first budget increase in eight years, the National Endowment for the Arts' current budget of $105 million is less than two thirds of its 1992 level. In contrast, the Arts Council of England has a FY 2000 appropriation equal to nearly $350 million. With a population one fifth that of the United States, the disparity in funding levels is huge, with the United States attaining only 6 percent of England's per capita national arts-agency funding. Adding in our state arts agencies' aggregate FY 2000 budget appropriations of $400 million, as compared to England's regional arts associations (approximately $150 million) and national arts lottery ($166 million) budgets, does little to decrease the disparity.

Grantmakers' initiatives need to be grounded in actual conditions and aspirations of the field. A few highly visible national foundations have been involved in supporting the field, most associated in our interviewees' minds with a particular approach driven more by the funder's internal culture and priorities than by systematic investigation of the field.

For instance, defining the work of community artists as an extension of "the arts" per se, rather than as a distinct field, some have focused on "audience development," supporting community artists in the hope that their work will yield guidance about how to broaden overall arts participation beyond existing barriers of race and class. The Lila Wallace-Reader's Digest Fund belongs in this category; the goal of its arts funding is "to promote new standards of practice to increase participation in the arts."

Other foundations have supported community artists as an expression of interest in intercultural and multicultural projects. Until the creation of PACT in 1995, with its emphasis on community cultural-development and problem solving, this had been the primary rationale for the Rockefeller Foundation's support to community cultural-development practitioners.

Still others have been associated with grand strategies that are often perceived by practitioners as unconnected to actual developments and needs within the field. Such funder-driven developments tend to subside when funding disappears. For instance, until its recent "Animating Democracy" initiative, a collaboration with Americans for the Arts that awards grants for arts groups engaged in "civic dialogue," the Ford Foundation in the '90s tended to invest in individual personalities, hitching its program to performance artist Anna Deveare Smith (a former Ford Foundation artist in residence) by underwriting her Institute on the Arts and Civic Dialogue project at Harvard for three years, just concluding. A number of those we spoke with in the course of this study were critical of Ford's failure to support people in the field with strong track records.

> *One of my frustrations has been looking at people thinking they're inventing this. Like all the Ford money going to Harvard, seeing if it's feasible: they think they're prototyping, even though everybody's saying, "You have people who've been doing this for years."*

The Animating Democracy initiative, which has channeled support to a number of PACT grantees and other accomplished community cultural-development organizations, appears to constitute a course correction welcomed by the field.

SOME SUGGESTED RESPONSES TO THE NEED FOR MATERIAL SUPPORT

Grantmakers should provide multiyear grants and general operating support, rather than stressing only project support. Every sector of nonprofit endeavor that has succeeded in developing adequate infrastructure, theoretical and critical frameworks, useful training programs and real visibility has been nurtured by public and private funders providing a base of reliable support, year in and year out, on which to build. Project grants make sense for special purposes, as part of a multifarious support

structure. But it's time to put them into perspective, with longer-term funding commitments leading the way to development of a field that has been "emerging" for decades without ever having the wherewithal to arrive.

Grantmakers with community cultural-development experience should share their knowledge with philanthropic colleagues. Each time we interview the members of a particular cultural field for a study on their work and its prospects, we close our interviews by asking participants if there is anything else they wish us to convey in our report. Almost without exception, they say the same thing: that they want to urge funders who do understand their work to convince their peers in the philanthropic community of its importance.

> *The role of a national foundation is to shine a light on something. There should be a process of bringing in other partners and this takes more time. You need to look at how the projects could be more successful and help open doors.*

It is a commonplace that the urgings of peers are more likely to be heeded than the entreaties of petitioners for support. What will it take to legitimate community cultural-development work in the eyes of the philanthropic community? Sympathetic funders can help to answer this question by considering their own learning curves and finding ways to replicate them for colleagues.

Researchers should focus on the unique economic realities of the community cultural development field, creating a body of solid information to counter the application of ill-fitting generalities to the field. Naturally, community artists would rather be funded than studied; but many studies are done and most of these omit them. Indeed, the category of "the nonprofit arts" is so large and so strongly skewed by the dominance of prestige arts institutions that research on the entire nonprofit arts sector has had practically no useful application to the community cultural-development field. In our view, there are several approaches that would help:

1) **Grantmakers underwriting new documentation and research into community cultural development history, theory and practice.** A few decades of experience in the field and a great many conversations with practitioners have led us to trustworthy conclusions about the field's conditions and needs. But most people have little or no access to the range of work and experience we've been able to observe. Part of the legitimation of community artists' work will be investing the resources and attention needed to study them just as other elements of cultural activity are studied, beginning with adequate support for community artists' documentation of their own work.

2) **Grantmakers ensuring that arts-related studies they help to fund make allowance for community cultural-development practice.** Designers of such studies usually assume that "the nonprofit arts" is a useful, all-purpose category. Because researchers have no experience with community artists, they don't even know what they are missing. In such cases, it might be necessary to predicate any grant on a more nuanced treatment of the nonprofit arts sector, one that explores useful distinctions within it; or to provide supplemental funding for the express purpose of adding a treatment of the community cultural-development field to a study originally designed without it.

3) Academic programs in areas related to arts and media practice, arts administration and research ensuring that the community cultural-development field is included in the curriculum. The conceptual laziness that treats "the nonprofit arts" as a fully encompassing category extends to academia as well. Students graduated without really encountering community cultural-development history, theory and practice will go on to repeat the omission when they go to work as arts administrators, funders or researchers.

While basic training for community cultural-development practitioners should stress on-the-job experience (threaded through with reading and discussion of issues, of course), there is certainly a need to encourage academic interest and facilitate collaborations between practitioners and academics to help legitimate the field. Fellowships that allow practitioners time away from daily work for study are one promising idea to promote interaction between practitioners and the academy. They could be applied to projects such as a critical analysis of a group's methodology; organizing documentation and carrying out interviews or other activities in aid of writing a group's history; or research into relevant historical periods, policies or social movements.

There is a need for grantmakers to allow well-considered research and genuine dialogue with members of the field to influence the shape and direction of their support programs. Over the years, convocations of community artists have reliably produced recommendations concerning the field's support needs, many of them repeated in this report. Why they have been so widely ignored could make an interesting study (as compared, for instance, with similar recommendations by museums, symphony orchestras and ballet companies, all of whom have been able to maintain collegial, collaborative relationships with funders through national professional organizations). But this is not as important as how they can begin to be heard. Internal training and dialogue opportunities for funding-agency staff members would help; presentations could be tailored to agencies' own priorities and focus, for example, stressing community cultural-development in particular regions of the world or in the framework of particular aspects of community development.

Community cultural-development practitioners should take advantage of networking and convening opportunities to explore key questions for the field, including these suggestions:

– *The project-grant addiction*: Are there ways community artists can come together to help funders break the project-grant addiction? Case studies, presentations at grantmakers' meetings, special sessions with grantmakers—is there anything that can be done to influence funders away from the preoccupation with novelty and "sexy" packaging of projects and toward more realistic, reliable modes of support?

– *Collaborating with academia*: What can community artists do to encourage research and study of their work, helping to ensure it is conducted with sensitivity? In what ways could academic attention or involvement truly help to advance the field?

Bus Riders Union press conference outside Los Angeles Metropolitan Transit Authority headquarters, displaying "*¡No Somos Sardinas!*/We Won't Stand for It!" posters by artist Robbie Conal protesting >

CONCLUSION **AN EPOCHAL OPPORTUNITY**

overcrowding on buses. Photo © Robert Gauther/Los Angeles Times 1998

CONCLUSION > AN EPOCHAL OPPORTUNITY

*Every person and every age may...be said to have at least two levels: an upper, public, illu-
minated, easily noticed, clearly describable surface from which similarities are capable of
being profitably abstracted and condensed into laws; and below this is a path into less and
less obvious yet more and more intimate and pervasive characteristics, too closely mixed
with feelings and activities to be easily distinguishable from them.... [W]hat we know on
this level of half-articulate habits, unexamined assumptions and ways of thought, semi-
instinctive reactions, models of life so deeply embedded as not to be felt consciously at
all—what we know of this is so little..., to claim the possibility of some infallible scientific
key where each unique entity demands a lifetime of minute, devoted observation, sympa-
thy, insight, is one of the most grotesque claims ever made by human beings.*[38]

From the perspective of 2000, it is tempting to view the 20th century as a particularly trying learning
experience. What can it honestly be said that we—as a species—have learned about the nature of
social change? Unfortunately, not the lesson this quotation from Isaiah Berlin suggests: that it is fool-
hardy to base a program of social change on quasi-scientific laws or principles that might be deduced
from the "upper, public" level of reality—what Berlin has called the "clear layer"—when the deep,
unknowable "dark layer" of human experience exerts just as much force on the course of events.

Thanks to the development of technology, enabling vast applications of social-engineering princi-
ples—laws of manifest destiny, of racial purity, of industrialization, of scientific agriculture—the past
century has been one of vast mistakes. The problem of how to correct them will surely occupy us well
into the 21st century, perhaps beyond.

Viewed through this lens, what is perhaps the key generative theme of the past century has been
beautifully articulated by the writer Carlos Fuentes:

*[T]he emergence of cultures as protagonists of history proposes a re-elaboration of our
civilizations in agreement with our deeper, not our more ephemeral, traditions. Dreams and
nightmares, different songs, different laws, different rhythms, long-deferred hopes, differ-
ent shapes of beauty, ethnicity and diversity, a different sense of time, multiple identities
rising from the depths of the polycultural and multiracial worlds of Africa, Asia and Latin
America....*

*This new reality, this new totality of humankind, presents enormous new problems, vast
challenges to our imaginations. They open up the two-way avenue of all cultural reality: giv-
ing and receiving, selecting, refusing, recognizing, acting in the world: not being merely
subjected to the world.*[39]

"The emergence of cultures as protagonists of history" is reflected in every facet of 20th century
history. One has only to consider the multiplication of independent nations: at the start of World War II,

38 Isaiah Berlin, *The Sense of Reality*, op. cit., pp. 20-21.

39 Carlos Fuentes, *Latin America: At War With The Past*, Massey Lectures, 23rd Series (Toronto: CBC
Enterprises, 1985), pp. 71-72.

there were 72 independent states; today, the United Nations' membership comprises 189. Merely listing a few of their names evokes the epic struggle for self-determination they exemplify: Armenia, Bangladesh, Brazil, Ghana, Poland, Senegal, Zimbabwe.

An incredible diversity of cultures has always existed. But it is in our times that they have taken center stage, become the protagonists of history. It is in our time that the "dark layer" of reality—people's attachment to language, customs, community, to "different songs, different laws, different rhythms, long-deferred hopes, different shapes of beauty, ethnicity and diversity, a different sense of time," in Fuentes' words—has become a reason to live and die with as much weight in determining the world's fate as the "clear layer" of macroeconomics, strategic alliances and political agendas.

To respond to these new conditions, we need tools that relate to the whole person, that take cultural values and meanings as seriously as do these new protagonists of history.

> *We need a critical analysis of how we can reconstruct a feudal world and build an economy democratically. Funding community-based, politically progressive cultural stuff that's savvy about the issues is one of the best ways to do this. It's active, participatory, concrete, democratically available. It provides a different kind of learning—full-bodied learning, not the European model of head-learning: the body is wired for more than this.*

Clearly, many different types of effort can advance social change: in a context of vibrant democratic discourse and action, grassroots movements and policy wonks are symbionts. But among all of these, community cultural-development practice is uniquely suited to respond to current social conditions, uniquely powerful in its ability to speak to the whole person, the whole community, nurturing and supporting communities' resilience, especially in the face of globalization:

– The heart of the work is to give expression to the concerns and aspirations of the poor and excluded, stimulating social creativity and social action, advancing social inclusion.

– It asserts the value of diversity and fosters an appreciation both of difference and of commonality within difference.

– In valuing both material and nonmaterial cultural assets of communities, it deepens participants' comprehension of their own strengths and agency, enriching their lives and their sense of possibility.

– It brings people into the civic arena with powerful tools for expression and communication, promoting democratic involvement in public life.

– It creates public, noncommercial space for full, embodied deliberation of policies affecting citizens.

– The work is inherently transnational, with strong roots in immigrant communities and deep commitments to international cooperation and multidirectional sharing and learning.

In the Information Age, when livelihood depends increasingly on mastery of cultural tools and ability to provide useful service, supporting this field will also help to develop an essential new form of sustainable livelihood for community artists and organizers, one with impressive potential for growth as its efficacy is demonstrated to the many public and private agencies in a position to support community cultural-development projects in their own sectors.

Much of this document has focused on live, in-person forms of cultural participation and the support needs of existing practitioners. But cyberspace provides a whole new terrain for cultural development, one which community artists are uniquely equipped to cultivate, with the aim of bringing new technology's democratic potential to fruition. With appropriate resources, it will be possible to go beyond support of the traditional modes of cultural-development work, extending the values of community cultural-development to computer-based media.

The effort to counter the effects of globalization is not an equal fight. The forces of globalization have virtually unlimited capital and influence on their side. Yet on the other side we have the relentless resilience of spirit that characterizes human cultures.

How we live depends to an astounding degree on the narratives we create to contextualize and interpret raw experience. People make art even under the most extreme conditions of deprivation and oppression: in refugee camps, prison wards, homeless shelters. Even without material resources, with only their bodies as tools, humans demonstrate wonder, agency, strength and creative power, giving meaning to the past and present, reimagining the future.

An essential task now is to mobilize those damaged by globalization—a category that encompasses the entire world—to realize and act on the causes of our suffering. Capital and influence are needed to turn the promise of community cultural-development work to this task.

Artistic practice in combination with almost any human activity increases the possibility of having depth in that human activity.

COMMUNITY CULTURAL-DEVELOPMENT GLOSSARY

Action-research describes a method of learning by doing. Community artists experiment with different approaches to gathering relevant material for a project, each of which produces new learning—different types of interactions, different results. Based on these experiments, the project's focus and core methods are determined.

Community describes a unit of social organization based on some distinguishing characteristic or affinity: proximity ("the Cambridge community"), belief ("the Jewish community"), ethnicity ("the Latino community"), profession ("the medical community") or orientation ("the gay community"). The word has more concrete meaning closer to the ground: "the gay, Jewish, academic community of Cambridge" probably describes a group of people who have a passing chance of being acquainted, whereas many of the more general formulations are ideological assertions. As Raymond Williams has put it,

> Community can be the warmly persuasive word to describe an existing set of relationships or the warmly persuasive word to describe an alternative set of relationships. What is most important, perhaps, is that unlike all other terms of social organization (state, nation, society, etc.) it seems never to be used unfavorably and never to be given any positive opposing or distinguishing term.[40]

In the context of community cultural-development, "community" describes a dynamic process or characteristic. There is general recognition that to be more than an ideological assertion, the bonds of community must be consciously, perpetually renewed.

Community Animation, from the French *animation socio-culturelle*, this is the common term for community cultural-development in Francophone countries. There, community artists are known as *animateurs*. This term was used in much international discussion of such work in the 1970s.

Community Arts is the common term for community cultural-development in Britain and most other Anglophone countries; but in U.S. English, it is also sometimes used to describe conventional arts activity based in a municipality, such as "the Anytown Arts Council, a community arts agency." While in this document we use "community artists" to describe individuals engaged in this work, to avoid such confusion, we have chosen not to employ the collective term "community arts" to describe the whole enterprise.

Community Cultural-Development describes a range of initiatives undertaken by artists in collaboration with other community members to express identity, concerns and aspirations through the arts and communications media, while building cultural capacity and contributing to social change.

Conscientization, from the Portuguese *conscientizao* of Brazilian educator Paulo Freire, is an ongoing process by which a learner moves toward critical consciousness. This process is the heart of liberatory education. It differs from "consciousness raising" in that the latter may involve transmission of preselected knowledge. Conscientization means breaking through prevailing mythologies to reach new levels of awareness—in particular, awareness of oppression, being an "object" of others' will rather than a

40 Raymond Williams, *Keywords: A Vocabulary of Culture and Society* (New York: Oxford University Press, 1976), p. 66.

self-determining "subject." The process of conscientization involves identifying contradictions in experience through dialogue and becoming part of the process of changing the world.

Critical Pedagogy is one name for the educational approach espoused by Paulo Freire; liberating or liberatory education is another. (See "conscientization," above.)

Cultural Action comes very close to being a synonym for cultural development: action undertaken through the arts for education, development and social impact. It is also employed by practitioners of critical pedagogy such as that proposed by Paulo Freire to describe educational interventions for development that make use of culture, such as reconceiving folktales to advance educational goals.

Cultural Democracy is the term for a philosophy or policy emphasizing pluralism, participation, and equity within and between cultures. Although it has roots in anti-Ku Klux Klan writings of the 1920s, it did not come into common usage until introduced as a policy rubric in Europe in the 1960s.

Cultural Equity describes the goal of a movement by artists and organizers, most from communities of color, to ensure a fair share of resources for institutions focusing on non-European cultures. The goal of cultural-equity organizing is to redress and correct historic imbalances in favor of European-derived culture.

Cultural Policy describes, in the aggregate, the values and principles that guide any social entity in cultural affairs. Cultural policies are most often made by governments, from school boards to legislatures and the executives of cultural agencies, but also by many other institutions in the private sector, from corporations to community organizations. Policies provide guideposts for those making decisions and taking actions that affect cultural life.

Cultural Work, with its roots in the panprogressive Popular Front cultural organizing of the '30s, emphasizes the socially conscious nature of the arts, stressing the role of the artist as cultural worker, countering the tendency to see art making as a frivolous occupation, a pastime as opposed to important labor.

Culture in its broadest, anthropological sense includes all that is fabricated, endowed, designed, articulated, conceived or directed by human beings, as opposed to nature. Culture includes both material elements (buildings, artifacts, etc.) and immaterial ones (ideology, value systems, languages).

Development (with its many subsets such as "economic development," "community development" and "cultural development") describes a process of analyzing the resources and needs of a particular community or social sector, then planning and implementing a program of interlocking initiatives to rectify deficiencies and build on strengths. The community cultural-development field stresses participatory, self-directed development strategies, where members of a community define their own aims and determine their own paths to reach them, rather than imposed development, which tends to view communities as problems to be solved by bringing circumstances in line with predetermined norms.

PACT (Partnerships Affirming Community Transformation) is a program of the Rockefeller Foundation's Creativity & Culture Division to support community cultural-development projects.

Participatory Research is an approach to social change—a process frequently used by and for people who are exploited and oppressed. The approach challenges the way knowledge is produced with conventional social-science methods and disseminated by dominant educational institutions. Instead of distinguishing the subjects of research from the researchers, it puts the gathering of knowledge into the hands of the people being studied.

Transnational refers to activities or systems that transcend national borders. The word embodies recognition of dynamic cultural processes that connect human societies regardless of official boundaries. In contrast to international, it also implies multidirectionality, rather than one- or two-directional exchange.

COMMUNITY CULTURAL-DEVELOPMENT SELECTED BIBLIOGRAPHY

Adult Education

Adult Learning and the Challenges of the 21st Century—CONFINTEA (Paris: UNESCO Publishing/UIE, 1999).

A series of 29 booklets documenting workshops held at the Fifth International Conference on Adult Education (CONFINTEA 1997). The booklets cover the following 10 main subjects: democracy and cultural citizenship; the quality of adult learning; literacy and basic education; empowerment of women; world of work; environment, health, population; media, culture; groups with special needs; economics of adult learning; and international cooperation.

International Council for Adult Education, Toronto, Ontario, Canada. ICAE's Web site can be found at <http://www.web.net/icae/eindex.htm>.

Many adult-education related documents, plus links to Freire and other critical pedagogy sites.

Critical Pedagogy

Paulo Freire, *Pedagogy of the Oppressed* (New York: Continuum, 1982).

First translated from Portuguese in 1968, this is the seminal work of the theorist who has been tremendously influential not only in education, but in all forms of democratic cultural work through-out the world. *Education for Critical Consciousness* (New York: Continuum, 1981), published in 1973, is more concrete and straightforward. Also see *Pedagogy of Hope: Reliving Pedagogy of the Oppressed* (New York: Continuum, 1994), published late in Freire's life.

Henry Giroux, *Pedagogy and the Politics of Hope: Theory, Culture and Schooling: A Critical Reader* (Boulder: Westview Press, 1997).

Part of a series on critical pedagogy—entitled "The Edge: Critical Studies of Educational Theory," edited by Joe Kincheloe, Peter McLaren and Shirley Steinberg—this compilation draws from 15 years of the author's writing, typifying the postmodern tone and vocabulary of much critical-pedagogy writing. Giroux, McLaren and others have made a minor industry out of critical pedagogy, but it is unfortunately self-referential, dealing primarily with the academy rather than community-based applications. Freire's own writing remains the most important source for people doing community-based work.

Cultural Policy and Cultural Development

Don Adams and Arlene Goldbard, *Crossroads: Reflections on the Politics of Culture* (Talmage, Calif.: DNA Press, 1990).

Collected essays from the 1980s, most on aspects of cultural policy and community cultural-development.

The Communication Initiative Web site can be found at <http://www.comminit.com>.

An extensive international database of development-related projects and resources.

Council of Europe, Council for Cultural Cooperation (CCC), Strasbourg, France.

The most current reference for the Council is its Web site at <http://culture.coe.fr/clt/eng/eculture.html>. A compendium of facts and trends in European cultural policies prepared for the Council by ERICarts can be found at <http://www.culturalpolicies.net>.

– *Towards Cultural Democracy* (1976) is a dense, thorough history of the development of cultural policy in Europe in the postwar period, commissioned for the pivotal Oslo Conference of the CCC in 1976 along with *Cultural Policy in Towns* by Stephen Mennell, an overview of the CCC's "Fourteen Towns" project. The latter work was subsequently updated with *Urban Life in the 1980s* (1983), edited by Brian Goodey, a collection of essays by participants in the CCC's expanded "Twenty-one Towns Project."

– *Socio-Cultural Animation* (1978) contains very interesting essays on community animation including policy, training and practice (an updated reprint of "Information Bulletin number 4," 1975). Also look for *Animation in New Towns* (1978) and Finn Jor's *The Demystification of Culture* (1976, also commissioned for the Oslo conference).

The U.S. distributor of Council of Europe publications on cultural policy and cultural development is Manhattan Publishing (P.O. Box 850, Croton-on-Hudson, N.Y. 10520; (914) 271-5194), which maintains a Web site at <http://www.manhattanpublishing.com>.

Culturelink (Zagreb: Institute for International Relations). Subscriptions from: Culturelink/IMO; Ul. Lj. F. Vukotinovica 2; P.O. Box 303; 10000 Zagreb, Croatia; $50/Year for institutions.

This periodical (issued regularly in April, August and November, with one additional special edition each year), offers the best ongoing information about developments in cultural policy worldwide. Published by Culturelink, which was established in 1989 as a joint initiative of UNESCO and the Council of Europe to serve as a "network of networks for research and cooperation in cultural development."

Culturelink's Web site, at <http://www.culturelink.hr>, provides access to databases on cultural policy and organizations worldwide. An excellent source of international links.

Augustin Girard with Geneviève Gentil, *Cultural Development: Experiences and Policies*, Sec. Ed. (Paris: UNESCO, 1983).

First published in response to UNESCO's first world conference on cultural policy, in Venice, 1970, this intentionally definitive text provides a good overall introduction to international cultural policy making, with extensive reference to cultural democracy and *animation socio-culturelle*.

Final Report, 1982 World Conference on Cultural Policies, Mexico City, Mexico, 26 July to 6 Aug. 1982 (Paris: UNESCO, 1982).

> Summarizes global thinking on cultural issues among policymakers just prior to Reagan's withdrawal of the United States from UNESCO. A number of reports issued in preparation for this World Conference take up such topics as the "Training of Cultural Animators," the last discussion on the topic in official UNESCO literature as far as we are aware.

Our Creative Diversity: Report of the World Commission on Culture and Development, Sec. Ed. (Paris: UNESCO Publishing, 1996).

> This background document for the most recent world conference on cultural policies (held in Stockholm in March–April 1998) reflects UNESCO's rhetoric in the post-Reagan period, broadening the scope of cultural policy and explicitly linking cultural policy to development.

World Culture Report 1998: Culture, Creativity and Markets, UNESCO World Reports (Paris: UNESCO Publishing, 1998).

> Presenting comparative data on culture and development and stressing the complexity of cultural indicators, this report addresses issues of globalization and identifies international trends, emphasizing the stimulating impact of intercultural contact.

Arie de Ruitjer and Lietke van Vucht Tijssen, editors, *Cultural Dynamics in Development Processes* (The Hague: UNESCO/Netherlands National Commission for UNESCO, 1995).

> A collection of essays on the cultural dimensions of development in such areas as education, health, sustainable agriculture and environmental quality, as well as issues such as ethics, governance and power relations and the role of women, prepared in connection with an international conference in June 1994 in Zeist, the Netherlands.

UNESCO's Web site can be found at <http://www.unesco.org>.

> The leading international source for cultural policy publications. A good place to order publications, search for links and read about international cultural-development initiatives.

Webster's World of Cultural Democracy can be found at <http://www.wwcd.org>.

> Nonprofit text-only site offers background materials on cultural policy and cultural-development practice.

Intergenerational Cultural Projects

Susan Perlstein and Jeff Bliss, *Generating Community: Intergenerational Partnerships through the Expressive Arts* (New York: ESTA, 1994).

A guide for community leaders to establish intergenerational arts programs, proceeding from general philosophy to creating partnerships and carrying out and evaluating programs.

Liz Lerman, *Teaching Dance to Senior Adults* (Springfield, Ill.: Charles C. Thomas, 1984).

A compendium of approaches to working with seniors developed by the Dance Exchange and its intergenerational performance company, Dancers of the Third Age, also proceeding from theory through workshop practices to performance and concluding with priorities for continuing development.

Oral History

Ronald J. Grele, *Envelopes of Sound: The Art of Oral History*, Sec. Ed. (New York: Praeger, 1991).

Originally published in 1975, then enlarged in 1985, this reprinted collection of essays was inspired by a 1973 meeting of the Oral History Association (OHA). It opens with Grele's interview of Studs Terkel and a transcript of a radio panel of oral historians distributed before the OHA meeting, then proceeds with essays on the issues they raised. Introduction for the general reader to methods and problems, and discussion of larger theoretical issues in the field.

Alessandro Portelli, *The Death of Luigi Trastulli and Other Stories: Form and Meaning in Oral History* (Albany: State University of New York Press, 1991).

The most poetic of the general introductions to oral history, providing an introduction to the field with extensive reference to material gathered by this leading practitioner and academic, concentrating especially on extended case studies of the author's work in Terni, Umbria, Italy and Harlan County, Kentucky, U.S. More recently, Portelli has published *The Battle of Valle Giulia: Oral History and the Art of Dialogue* (Madison: University of Wisconsin Press, 1997), focusing on "multi-vocal" approaches to oral history.

Paul Thompson, *The Voice of the Past: Oral History*, Sec. Ed. (Oxford University Press, 1988).

First published in 1978, a presentation of oral history from general principles through collection and use of oral sources by historians. Considered the field's basic text and also, to quote Grele in introducing *Envelopes of Sound*, a "fairly traditional view of the historical enterprise."

The Oral History Association, Dickinson College, P.O. Box 1773, Carlisle, Pa. 17013-2896:

– "Oral History Evaluation Guidelines: Guidelines and Principles of the Oral History Association," Pamphlet Nov. 3, 1992. Out of print, but available on the Web at <http://omega.dickinson.edu/organizations/oha>.

– "Using Oral History in Community History Projects," by Laurie Mercier and Madeline Buckendorf. A solid introduction for the community practitioner.

Popular Theater

Augusto Boal, *Theatre of the Oppressed* (New York: Urizen Books, 1979).

> Inspired by Freire's theory, Boal's 1974 work was published in English with this edition and has become widely influential among those leading community cultural-development projects using theater. Boal's more recent publications include *The Rainbow of Desire: The Boal Method of Theatre and Therapy* (London: Routledge, 1995), a more extensive discussion of practical approaches and *Legislative Theatre: Using Performance to Make Politics* (London: Routledge, 1999), describing Boal's use of "forum theatre" to involve the public in his legislative role as *Vereador* (member of the municipal Parliament) in Rio de Janeiro.

Richard Schechner and Mady Schuman, *Ritual, Play and Performance: Readings in the Social Sciences/Theatre* (New York: Seabury, 1976).

> This collection of essays, preceding translation of Boal's work into English, provides a survey of other sources of theoretical grounding and practical approaches to socially engaged theater during this period.

Jan Cohen-Cruz, *Radical Street Performance: An International Anthology* (London: Routledge, 1998).

> A collection of 34 essays portraying a wide variety of community-based theater projects in the Americas, Europe, Africa and Asia. Cohen-Cruz also co-edited with Mady Schutzman *Playing Boal: Theatre, Therapy, Activism* (London: Routledge, 1994).

Institute for Cultural Policy Studies, *We Are Strong: A Guide to The Work of Popular Theatres Across The Americas* (Mankato, Minn.: Institute for Cultural Policy Studies, 1983). Out of print.

> A directory, with essays, of popular theaters active in the 1970s and early 1980s.

Ross Kidd, *The Popular Performing Arts, Non-Formal Education and Social Change in the Third World: A Bibliography and Review Essay* (The Hague: Centre for the Study of Education in Developing Countries, 1982).

> A comprehensive survey of published material on the international Third World popular theater movement, including a 24-page essay by Kidd, a leading exponent of this movement, outlining the history and development of "theater for development." Indices identify sources by country as well as by theatrical genre and issue area (e.g., politics, family planning, health and nutrition, and agriculture).

Richard Boon and Jane Plastow, editors, *Theatre Matters: Performance & Culture on the World Stage* (Cambridge University Press, 1999).

> A new presentation of projects where "theater for development" has made a real social or political impact and of the issues raised by such work. Includes chapters on Nigeria, South Africa, Eritrea,

Caribbean, Canada (Native American), Jamaica, India, Brazil and Argentina. Plastow is a MAP Fund grantee, having directed the Eritrean Theater project undertaken by the University of Leeds.

"Applied and Interactive Theatre Guide" Web site can be found at <http://pages.nyu.edu/~as245/AITG>

"...a resource for those who use theatre techniques for other or more than arts or entertainment purposes and for those whose theatre styles incorporate other than traditional presentation styles." This site contains links to just about every Boal-inspired, community or instrumental-theater approach.

The New Deal

Hallie Flanagan, *Arena* (New York: Duell, Sloan & Pearce, 1940).

A fascinating first-hand account of the Federal Theatre Project (FTP), that vibrant, though short-lived experiment in a truly public American theater, by its dynamic national director. Apart from the underlying philosophy and aims of the FTP, *Arena* offers one of the most detailed accounts of the activities of the dozens of local companies which the Project comprised.

Jerre Mangione, *The Dream and the Deal: The Federal Writers' Project, 1935-1943* (New York: Avon, 1972).

A complete presentation of the longest-lasting of the New Deal cultural programs, the Federal Writers' Project.

Richard D. McKinzie, *The New Deal for Artists* (Princeton University Press, 1973).

A complete historical account of the Federal Art Project (FAP) and its antecedent New Deal programs for visual artists.

Milton Meltzer, *Violins & Shovels: The WPA Arts Projects* (New York: Delacorte, 1976).

A general introduction to all the component projects of Federal One, less detailed than each of the other resources listed here, but inclusive of all the projects.

Francis V. O'Connor, ed., *Art for the Millions: Essays from the 1930s by Artists and Administrators of the WPA Federal Art Project* (Boston: N.Y. Graphic Society, 1975).

First conceived as a national report on the FAP, compiled in the '30s but never published, then retrieved, reworked and published for the first time by an important archivist of New Deal visual-arts material. A fascinating collection of first-person sources from the Project, along with a contextualizing essay by the editor.

The New Deal Network Web site can be found at <http://newdeal.feri.org/>.

An "educational Web site sponsored by the Franklin and Eleanor Roosevelt Institute and the Institute for Learning Technologies at Teachers College/Columbia University." This site has links to information about every New Deal-related cultural project.

Other Community Arts

Art in the Public Interest's Web site can be found at <http://www.apionline.org>.

> This site covers back issues of *High Performance* as well as links to other community arts-related sites and a link to <http://www.communityarts.net>, the Web site of the Community Arts Network, which features a community arts "reading room," links to the online newsletter *API News* and to many cultural development-related sites.

Linda Frye Burnham and Steve Durland, editors, *The Citizen Artist: 20 Years of Art in the Public Arena* (New York: Critical Press, 1998).

> An anthology of writings from the journal *High Performance*, focused on the changing role of the artist.

Eva Cockcroft, John Weber and James Cockcroft, *Toward a People's Art: The Contemporary Mural Movement* (New York: E. P. Dutton, 1977),

> Still the best overview of community-based mural-making.

Lucy R. Lippard, *The Lure of the Local: Senses of Place in a Multicentered Society* (New York: The New Press, 1997).

> An extended treatment of the sense of place and its many manifestations in culture and politics, focused by extensive material on site-specific community-based art. See also *Get the Message? A Decade of Arts for Social Change* (New York: E. P. Dutton, 1984); and *Mixed Blessings: New Art in A Multicultural America* (New York: Pantheon, 1990).

Mark O'Brien and Craig Little, editors, *Reimaging America: The Arts of Social Change* (Philadelphia: New Society Publishers, 1990).

> An anthology on social change-oriented arts work, featuring essays by practitioners on many aspects of community cultural-development practice.

Marjorie Patten, *The Arts Workshop of Rural America: A Study of the Rural Arts Program of the Agricultural Extension Service* (New York: Columbia University Press, 1937).

> An interesting account of arts extension programs and approaches in the early 1900s, with detailed information about each state's programs.

Arlene Raven, *Art in the Public Interest* (Ann Arbor: UMI Research Press, 1989).

> An anthology of essays on public visual artwork, featuring essays from several community artists.

AUTHORS AND APPROACH

This volume is based on a study commissioned to assist the Rockefeller Foundation's Creativity & Culture Division in formulating the best approaches to supporting community cultural-development, given the basis, scope, significance and potential of that work. In our original study, submitted on Dec. 14, 1999, we focused on the projects and community artists funded by the Foundation's PACT program (Partnerships Affirming Community Transformation).

As part of our research, we reviewed the complete archives of the Foundation's PACT program, as well as other materials provided by Foundation officers, PACT participants and others who agreed to assist us. Online and library searches supplemented these investigations. In addition, having worked with this field for nearly 30 years, we maintain our own extensive archive of documentary materials and publications which we were able to draw on.

But direct contact with community artists and organizations was paramount. In preparing the study on which this volume is based, we conducted confidential telephone interviews with 33 individuals involved in the field, including PACT grantees, other community artists and theoreticians and Foundation staff and consultants currently or formerly involved with PACT. We also drew on other interviews we had previously conducted for two earlier Rockefeller Foundation-commissioned studies. Interviewees are listed in the next section.

Interviews were confidential to ensure that participants were comfortable in providing full and frank comments on topics ranging from their own work to the field's needs and the obstacles in its path. Unless specifically attributed to another source, all quotations in this volume are taken from interviews.

Since January 1978, we have worked as partners in Adams & Goldbard, consulting with a wide variety of public and private agencies, most of them involved in cultural policy, artistic production and distribution, and cultural development planning and evaluation. Our work has integrated research, writing, planning, program and financial development, group dynamics, organizational restructuring and cooperative problem-solving.

Our many clients in the community cultural-development field have ranged from the American Festival Project to the Seattle Department of Parks and Recreation. In addition, we have done a great deal of work in the independent media field for dozens of clients such as the Independent Television Service, Web Lab, New Day Films and the Paul Robeson Fund for Film and Video. We have often worked with such groups to undertake stem-to-stern assessments of program, organization and support, integrating all these interlocking concerns. In other cases, we have planned and evaluated programs, conducted research, produced conferences and meetings or focused on organizational development issues. We have also spoken and published frequently on topics relating to cultural development and cultural policy.

DON ADAMS AND ARLENE GOLDBARD
Seattle, Washington
November 2000

ACKNOWLEDGEMENTS

We are grateful for the assistance of former Creativity & Culture Senior Program Assistant Julie Bauer, who managed the Rockefeller Foundation's PACT program at the time we undertook this project; of current PACT officer and Creativity & Culture Associate Director Tomás Ybarra-Frausto; and of Acting Creativity & Culture Director Lynn Szwaja, Associate Director Joan Shigekawa and Program Associate Peter Helm, all of whom took part in planning this study. Creativity & Culture Program Assistants Michelle Hayes (current PACT program manager), Pam Johnson, Rose Marie Minore and Scott MacDougall were gracious in providing assistance as needed. The staff of the Foundation's Records and Library Services Division provided timely and efficient assistance in carrying out our research: we are particularly grateful to David Montes, Robert Bykofsky, Dottie Lopez and Elizabeth Peña. Andre Oliver and Susan Muir of the Foundation's Communications office ably assisted with publication arrangements, proofreading by Gretchen MacLane and V. Tobi Kanter and design by Lisa Billard Design, N.Y.

Background Interviews

In preparing the study on which this volume is based, we conducted confidential telephone interviews with the following 33 individuals involved in the field, including PACT grantees, other community artists and theoreticians and Foundation staff and consultants currently or formerly involved with PACT. Our thanks to these individuals who gave so generously of their time and thoughtful observations.

Anne Arrasmith and Peter Prinz, Space One Eleven, Birmingham, Ala.

Alberta Arthurs, consultant, former Director, Creativity & Culture, New York

Caron Atlas, PACT consultant, New York

Judith Baca, Social & Public Art Resource Center, Venice, Calif.

Julie Bauer, former PACT staff manager, New York

Ron Chew, Wing Luke Asian Museum, Seattle

Mary Marshall Clark, Oral History Research Office, Columbia University

Kathie deNobriga, consultant, Atlanta

Steve Durland, Art in the Public Interest, Saxapahaw, N.C.

Juana Guzman, Mexican Fine Arts Center Museum, Chicago

Karen Hayes, Youth for Social Change, Durham, N.C.

Peter Helm, Foundation Program Associate, New York

Maria-Rosario Jackson, The Urban Institute, Washington, D.C.

Lillian Jiménez, consultant, New City, N.Y.

Valerie Lee, Minneapolis Foundation, former director of Asian American Renaissance, Saint Paul

Liz Lerman, The Dance Exchange, Silver Spring, Md.

Julia Lopez, Director, Working Communities, Rockefeller Foundation

Lian Hurst Mann, Labor/Community Strategy Center, Los Angeles

Beni Matías, Center For Arts Criticism, Minneapolis

Doug Paterson, Theater Department, University of Nebraska at Omaha

Peter Pennekamp, Humboldt Area Foundation, Eureka, Calif.

Susan Perlstein, Elders Share the Arts, New York

Graciela Sanchez, Esperanza Peace & Justice Center, San Antonio

Suzanne Sato, AT&T Foundation, former Associate Director, Creativity & Culture, New York

Joan Shigekawa, Associate Director, Creativity & Culture

Linda Shopes, Pennsylvania Historic & Museum Commission

Lynn Szwaja, Acting Director, Creativity & Culture

Leslie Tamaribuchi, Cornerstone Theater Company, Los Angeles

Jack Tchen, Asian/Pacific/American Studies Program & Institute, New York University

Roberta Uno, New WORLD Theater, University of Massachusetts, Amherst

Tomás Ybarra-Frausto, Associate Director, Creativity & Culture

Lily Yeh, Village of Arts and Humanities, Philadelphia

Steve Zeitlin, City Lore, New York

In addition, we were able to draw on other interviews we had conducted over the last two years in our previous projects for the Foundation's Creativity & Culture Division: evaluations of the Film/Video/Multimedia Fellowships program and the Multi-Arts Production (MAP) Fund. Among the interviewees for these earlier projects were a number of community artists (and others employing community cultural-development approaches), including:

Elizabeth Barret, Appalshop filmmaker

Martha Bowers, choreographer

Pat Graney, choreographer

Bill T. Jones, choreographer

Rhodessa Jones, Cultural Odyssey

Annie Lanzillotto, performance artist

Ruby Lerner, Creative Capital Fund

Linda Mabalot, Visual Communications

Laurie McCants, Bloomsburg Theatre Ensemble

Robbie McCauley, performance artist

Keith Antar Mason, performance artist

Lisa Miller, theater/media activist

Mimi Pickering, Appalshop filmmaker

Marty Pottenger, community artist

Bill Rauch, Cornerstone Theater

Martha Wallner, community media activist

MK Wegmann, Junebug Productions

Marc Weiss, Web Lab

Jawole Willa Jo Zollar, Urban Bush Women